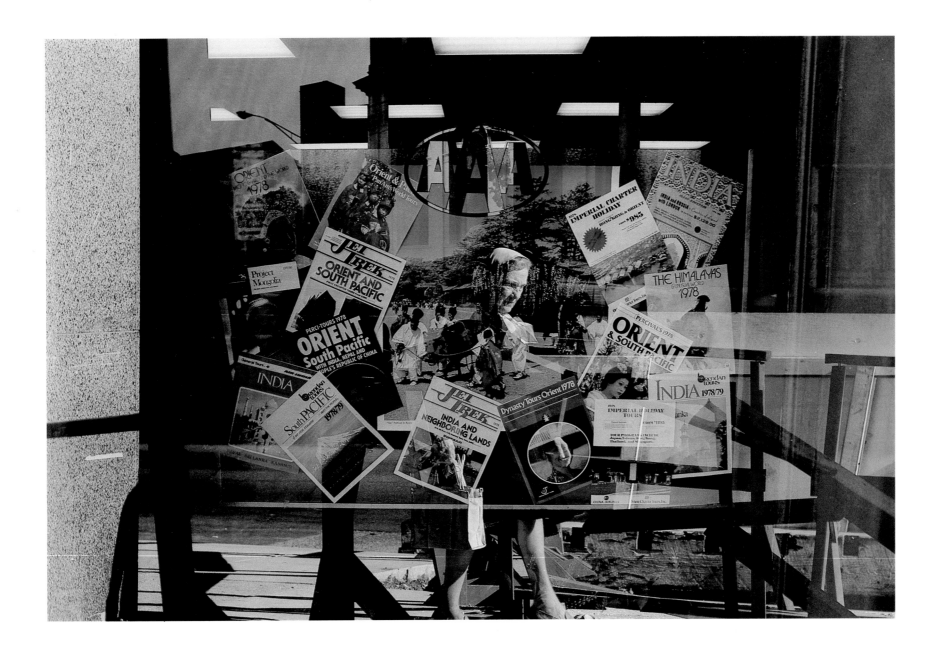

Providence, 1978

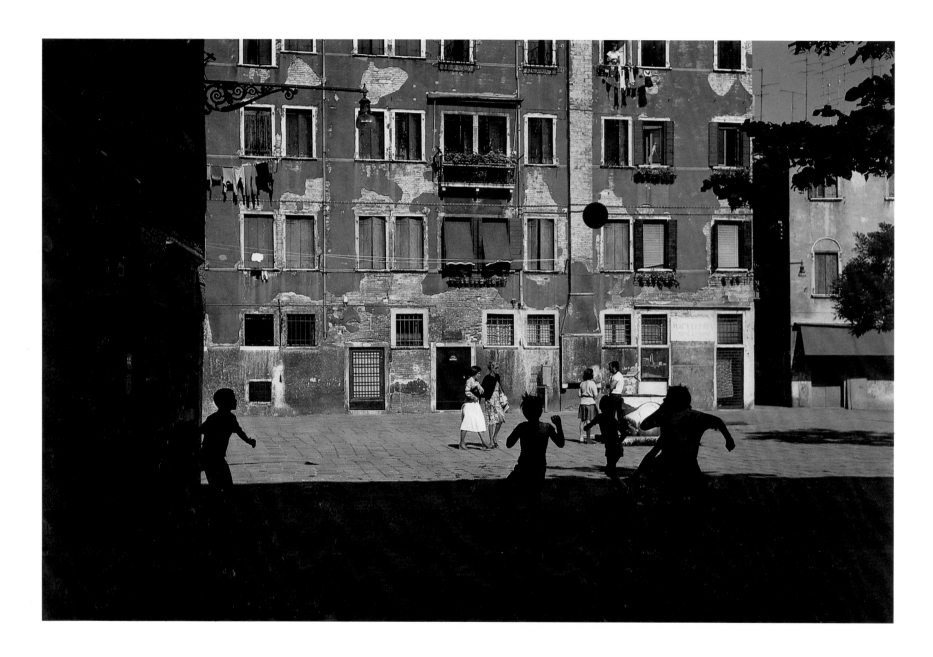

Venice, 1978

HARRY CALLAHAN

NEW COLOR

Photographs 1978-1987

KEITH F. DAVIS

HALLMARK CARDS, INC.
KANSAS CITY, MISSOURI

This book was published on the occasion of the traveling exhibition *Harry Callahan: New Color*, organized by, and from the holdings of, the Hallmark Photographic Collection. This Collection is a project of Hallmark Cards, Inc., Kansas City, Missouri, and reflects a larger company philosophy of support of the fine arts and community service.

All works illustrated in this book are drawn from the Hallmark Photographic Collection, with the following exceptions: Balthus, *The Street*, 1933 (Museum of Modern Art), and Pierre Bonnard, *Dining Room on the Garden*, 1934 (Guggenheim Museum).

All black-and-white figure illustrations are from original gelatin silver prints. All color plates are reproduced from original dye-transfer prints with an image size of $9^{5}/_{8}$ x $14^{1}/_{2}''$ (with the exception of page 37, 7 x $10^{1}/_{2}''$).

Designed by Malcolm Grear Designers, Providence, Rhode Island

Distributed by the University of New Mexico Press

ISBN: 0-87529-624-6 (cloth)
 0-87529-625-4 (paper)

Cover: Morocco, 1981
Printed in the United States of America

Introduction

This book surveys the most recent aspect of Harry Callahan's distinguished career: his exclusive devotion to color photography. Long admired for his eloquent work in black and white, Callahan has received considerable attention since 1980 for his pioneering work in color.[1] He began using color materials in 1941, and worked intermittently in this medium until 1964. Little use was made of color from that time until the mid-1970s, however.[2] In 1977, after a major retrospective of his black-and-white work at the Museum of Modern Art, Callahan turned entirely to color.

This shift in artistic emphasis was the result of several factors. Callahan felt somewhat overwhelmed by the quantity of black-and-white imagery he had produced in nearly forty years of work, and by the number of recent images that required proofing and printing. He turned to color, in part, to give himself time to catch up on this printing. More significantly, however, Callahan felt he had solved most of the visual problems that interested him in the monochromatic medium. Color offered new complexities and challenges, and a fresh opportunity to discover the world through the camera. Further, the ease of shooting 35mm slides freed him from the effort of using larger cameras and the tedium of darkroom work. He was thus able to simplify his process to — nearly — the pure act of seeing.[3] In 1983 Callahan stated that this interest in color "totally changed my life. I won't shoot anything else. I love it in magazines, billboards, and I even love watching color television."[4]

While some of his 1977-79 color work was included in a large 1980 monograph, the scope and vitality of Callahan's new color imagery has not been fully assessed until now. It is hoped that this book and accompanying exhibition serve to acquaint a larger audience with this most recent facet of Callahan's remarkable career. The purview of this study, 1978-87, serves to reflect the various aspects of Callahan's recent artistic production while avoiding duplication with earlier volumes.[5]

This publication marks Harry Callahan's fiftieth year as a photographer. In this half-century of work, Callahan has established himself as one of the most original and influential artists in the medium's 150-year history. As both artist and teacher he has changed the way we think about the possibilities of photographic expression, and about the relationship between art and life.

Callahan purchased his first camera in 1938, while working as a clerk for the Chrysler Motor Company. He photographed with little direction until 1941, when Ansel Adams conducted a workshop at the Detroit Photo Guild. Adams's photographs and passion for the medium opened Callahan's eyes and freed him to work in his own way, intuitively and intensively.

In the next few years Callahan explored the syntax and expressive possibilities of the medium in a completely unprecedented manner. He worked with cameras of varying formats, from 35mm to 8x10″, to explore the very different ways these instruments picture the world. The structure of the frame itself interested him: the height-to-width ratios of the 35mm (2:3), 2¼″ (1:1), and 8x10″ (4:5) cameras all presented different kinds of visual problems and possibilities.[6] Callahan explored the tonal extremes of print making, from richly detailed full-scale prints to elegantly reductive high-contrast images. In addition to this black-and-white work, he also explored the artistic applications of color. And he experimented endlessly with multiple exposures, fascinated by the camera's ability to transform the physical world into a picture universe of flickering transparencies and weightless, interpenetrating forms.

Equipped with this array of visual tools, Callahan proceeded to make pictures of the people and things around him. His characteristic themes became the urban scene, nature, the nude, his family, and the varieties of photographic abstraction. As a group these pictures are reticent, deeply felt, and prodigiously original. They suggest the profound beauty of the simple and familiar, and the artistic value of persistent hard work.

Hallmark first purchased and exhibited the work of Harry Callahan in 1964. This acquisition stemmed from the company's tradition of support for the visual arts, and from the friendship between Callahan and Hallmark executive David L. Strout. Hallmark began collecting contemporary art in 1949, when it sponsored the first of five International Art Awards. In the course of this program, which ran through 1960, paintings by Charles Sheeler, Edward Hopper, Fairfield Porter, David Park, and many others were acquired and exhibited in leading museums. This activity directly reflected the interest and values of company founder Joyce C. Hall (1891-1982) and his son, current chairman of the board, Donald J. Hall. The art collection has continued to grow

over the years, and presently includes over 1,000 paintings, prints, and dimensional works.

Within the context of this corporate commitment to fine art, the friendship between Callahan and Strout provided a catalyst for the company's involvement with fine photography. Strout, who studied painting at the Rhode Island School of Design, had developed an early enthusiasm for photography. In the spring of 1948, while an instructor in painting and drawing at Kenyon College, in Ohio, Strout met Callahan during a visit to Chicago. They were introduced by Joe Munroe, a freelance journalist and mutual friend.[7] Strout enjoyed Callahan's company and considered his photographs remarkable. An exhibition at Kenyon was arranged for the following academic term and Callahan and his wife attended the opening. A few years later, when Strout was working as academic head of the Kansas City Art Institute, he again offered Callahan an opportunity to exhibit his work. A show of about eighty prints was presented in the school's gallery, January 3-19, 1956.

Callahan's move in 1961 from the Institute of Design in Chicago to the Rhode Island School of Design in Providence was also due, in part, to Strout's impetus. At this time Strout was vice-president at R.I.S.D., with responsibility for faculty and curriculum development. He was eager for the school to develop a serious photography program and felt that Callahan was eminently qualified to head such a department. Indeed, Callahan overcame considerable institutional inertia to develop one of the finest academic programs in photography.

Strout left Providence in 1963 to work for Hallmark Cards. He was given initial responsibility for the planning of the company's prestigious new store at 720 Fifth Avenue in New York, scheduled to open in the summer of 1964. The centerpiece of the Hallmark Gallery store was a high-quality space for changing exhibitions. As part of his effort to structure a varied and innovative exhibit schedule, Strout suggested to Callahan in late 1963 that they mount a major retrospective of his work. Callahan agreed and played a determining role in the selection and presentation of his photographs.[8] *Harry Callahan: Photographer*, the gallery's second exhibition, opened on August 18, 1964, with 141 black-and-white prints and 60 color slides shown by continuous projection. The exhibition, which ran through October 10, was Callahan's first one-man retrospective in New York City, and was well received by both public and critics. All the black-and-white prints in the show were purchased by Hallmark and later toured to a number of university museums.

Other significant photographic exhibitions were presented at the gallery in the following years. These included *Carl Sandburg: A Tribute* (1968), with photographs by Edward Steichen, *Young Photographers: Students of Harry Callahan at the Rhode Island School of Design* (1969), *Henri Cartier-Bresson's France* (1971), and *André Kertész: Themes and Variations* (1973).

While the gallery's exhibition program ceased in 1973, the Hallmark Photographic Collection continued to grow in the company's Kansas City headquarters. At present the collection includes 1,800 photographs by some 185 leading twentieth-century artists, with 270 prints by Callahan. In recognition of the centrality of Callahan's work to the overall collection, a special interest has been taken in those photographers who have been associated with him in important ways: Laszlo Moholy-Nagy and Alfred Stieglitz as "mentors"; Arthur Siegel, Todd Webb, and Aaron Siskind as friends and peers; and Art Sinsabaugh, Ken Josephson, Ray Metzker, Joseph Sterling, Charles Swedlund, Joseph Jachna, Linda Connor, Emmet Gowin, and others, as students. Additions to the collection by these photographers reflect Callahan's stature as a teacher, while suggesting larger issues of style and influence.

Our Callahan collection has been exhibited numerous times in recent years. A black-and-white retrospective of 120 prints began a two-year national tour in January 1981 at the Spencer Museum of Art of the University of Kansas. In 1983 a large retrospective of both monochromatic and color work was presented at the Art Gallery of Ontario, in Toronto, Canada. And in 1986-87 a full-career survey of 115 prints toured to the major art museums in Honolulu, Hawaii; Auckland, New Zealand; and Melbourne, Sydney, and Brisbane, Australia. The present catalog and exhibition build on these past activities while concentrating on a fresh and less familiar aspect of Callahan's career.

We are very grateful to the many individuals and institutions that have assisted us in the course of this project. The director and staff of Pace/MacGill Gallery, Peter MacGill, Amy Brady Legg, and Linda Fiske, coordinated the production of Callahan's newest prints and helped in a variety of other ways. F. C. Gundlach of P.P.S., and Kurt Kirchner of Creative Color in Hamburg, Germany, produced superb dye-transfer prints of forty new images specifically for this project. The quality of Creative Color's work establishes the current standard for artistic dye-transfer production. J. Malcolm Grear, a long-time friend and teaching associate of Callahan, designed this volume with great sensitivity. We are grateful to him and the staff of Malcolm Grear Designers, in Providence, Rhode Island, for their enthusiasm for this book.

We are also grateful for assistance in assembling the bibliography and chronology of this book. Dolores A. Knapp, the artist's sister-in-law, has for years maintained a file on Callahan's career. She has generously shared this data with us and assisted in tracking down various related bits of information. Amy Rule of the Center for Creative Photography, Tucson, Arizona, kindly provided copies of Callahan announcements and reviews in their extensive files. Also very helpful were: Duncan Grey, Hallmark Cards N.Z. Limited, Auckland; Russell Baker and David Liddle, Hallmark Cards Australia Limited, Clayton, Victoria; and the staffs of the J. B. Speed Art Museum, Detroit Institute of Arts, Art Institute of Chicago, San Francisco Museum of Modern Art, and Georgia State University Art Gallery.

We are grateful to the Museum of Modern Art for permission to reproduce Balthus' *The Street*, 1933, and to the Guggenheim Museum for permission to reproduce Pierre Bonnard's *Dining Room on the Garden*, 1934.

Thanks to Dana Asbury of the University of New Mexico Press for her editorial advice and assistance.

This project stems from a larger company interest in the arts and in the creative public use of our collections. These attributes, and the particular interest in fine photography, directly reflect the concerns and commitment of Donald J. Hall, Chairman of the Board. Deep thanks also go to Hallmark personnel William A. Hall, Sally Hopkins, Pat Fundom, Mike Pastor, and Rich Vaughn for their invaluable support and assistance.

And, finally, our sincere thanks go to Harry and Eleanor Callahan for their kindness, cooperation, and enthusiasm for this project.

K.F.D.

FOOTNOTES

1. The publication of *Harry Callahan: Color* (Providence: Matrix Publications, 1980) is particularly important in this respect.
2. Sally Stein, in *Harry Callahan: Photographs in Color* (Tucson: Center for Creative Photography, 1980) noted that Callahan worked in color only twice between 1964 and 1977. He shot a few rolls of window displays in 1969, and two years later made a group of multiple exposures of Providence buildings.
3. For Callahan's reasons for turning to color, see Melissa Shook, "Callahan," in *Photograph* (New York), Summer 1977, p. 3; and Charles Hagen, "Late Color," in *Camera Arts*, July 1983, pp. 22, 72. In a recent conversation Callahan also was quick to credit historian Sally Stein for his renewed interest in color. He recalls that Stein's enthusiasm for his color slides in the archives of the Center for Creative Photography, in Tucson, Arizona, led her to propose an exhibition of this material. With the assistance of James Enyeart, Director of the Center, funds were raised to make dye transfers of a select number of these images. Callahan himself went to Tucson and selected several dozen images to be printed. Callahan's dealer in New York took an immediate interest in the project, and began exhibiting and selling this work.
4. Quoted in Valerie Brooks, "Harry Callahan's True Colors," *Art News*, October 1983, p. 66.
5. The Matrix publication, for example, reproduces 54 images from 1977-79. Only one of these, from the 1979 Ireland series, is also included in the present volume.
6. Callahan's exploration of the frame has been remarkably varied and subtle. For example, in 1945 he experimented briefly with the 6½ x 8½" format. And four years later he masked the back of his 8 x 10" camera to make 4 x 10" photographs. See "Sign Detail, New York, 1945" (p. 13) and "Wisconsin, ca. 1949" (p. 15) in the 1981 Hallmark catalog.
7. Munroe had known Callahan since the days of the Detroit Photo Guild. See his article "Harry Callahan," *Infinity*, January 1965, pp. 16-23.
8. Callahan presented the photographs very simply in thin metal Kulicke frames, without mats.

The Rhythms of the City *Continuity and Change in the Work of Harry Callahan*

Throughout the course of his long career, Harry Callahan's most consistent subject has been the city. His pictures of Detroit, Chicago, Providence, and New York provide touchstones for his creative life while suggesting a collective artistic portrait of the modern urban environment. The present selection of photographs surveys Callahan's artistic activity over the past decade while focussing on the theme of the city. This emphasis reveals the evolution and continuities of some of his basic pictorial motifs.

In his half-century of work Callahan has often explored several of his basic themes concurrently. In a number of instances his best-known nudes, landscapes, and architectural images were made within periods of a few days or weeks. At other times he has worked primarily with one theme or another, returning, for example, to downtown Providence or the beaches of Cape Cod to the exclusion of other subjects. Throughout his career Callahan has trusted and followed his instincts, working in a given place or with a particular idea only as long as it held vitality for him.

While the flexibility to shift his attention or technique has always typified Callahan's working method, the city has remained central to his vision. By comparison, Callahan's best-known photographs of his wife, Eleanor, and daughter, Barbara, were all made before 1960. This series ended when Barbara was old enough to protest the repeated ritual of posing and Eleanor returned to work full time. For less specific reasons, Callahan has also expressed a lessened interest in the natural landscape. "Walking around in the woods to photograph just isn't something that interests me anymore."[1] Instead, he finds himself attracted to the structure and dynamism of urban spaces.

The following essay attempts to locate Callahan's recent work within a larger biographic and artistic frame of reference. Given the quality of the existing literature on Callahan and the selected focus of this book, a full biography has not been attempted.[2] However, Callahan's early years, friendships, and influences will be briefly outlined, and his black-and-white city photographs surveyed. Finally, Callahan's work since 1978 will be considered as a logical extension of his tradition of change within clearly established artistic limits.

fig. 1 Todd Webb
Harry Callahan, New York, November, 1945

diversity of human interactio[n]
and social terms.¹⁹ The partic[ular]
fundamental ambivalence ab[out]
the city has evoked a series o[f]
community/alienation, utopi[a]
freedom/regimentation.

Many nineteenth- and t[wentieth]
fascinated by the dynamism
discourse it stimulated. Th[e]
changing. In contrast to the r[ural]
cities promised untold possib[ilities]
life was most strongly felt,
opportunity for new beginnin[g]

Such optimism was not u[niversal]
of the city involves all the fam[iliar]
the mechanization of life, ar[e]
community. The rapid pace o[f]
a nervous, or even neurotic, e[nergy]
have repeatedly portrayed t[he]
threatening forms filled wi[th]
"walking dead." This city i[s]
individual powerlessness ser[ves]
soullessness of modern cultur[e]

Twentieth-century art,
endless series of variations on
been treated as a symbol for t[he]
optimistic and pessimistic view[s]
tory feelings toward the civili[zation]

The city has been a centr[al]
of-the-century Pictorialists su[ch]
Edward Steichen rendered Ne[w]
muted tones to express a moo[d]

techni[
expost[
Th[
repres[
techni[
Nagy's[
least s[
import[
ences, [
Bu[
import[
graphe[
produc[
with a[
himsel[
was a h[
best by[
the ide[
was als[
and ch[
recolle[

*Th[
of [
gro[
Be[
fini[
ses[
our[
cit[
and[
see[
rec[
pho[
son[*

Harry Morey Callahan's early life was exceedingly conventional. He was born on October 22, 1912, the son of Harry Arthur Callahan, a Detroit factory worker. Attracted by Henry Ford's wages of five dollars a day, the senior Callahan had left his farm to move to Detroit several years before his son's birth. In high school Callahan was an indifferent student with little interest in academic achievement for its own sake. After attending Michigan State University for five terms, he quit in 1936 to marry Eleanor Knapp and find a job.[3] In the depths of the depression Callahan was fortunate to find employment at Chrysler Motor Company through a friend whose father was a vice-president at the firm. Callahan worked as an office clerk, a position he found tolerable but unstimulating.

Callahan compensated for the routine of his job by avidly pursuing outside activities. He played golf regularly and well, shooting in the seventies.[4] He enjoyed the challenge of the game, which required concentration, a sense of touch, and persistence. Golf was also fun, and Callahan enjoyed walking out-doors. When he discovered photography in 1938 Callahan's interest in golf ended because, it may be surmised, the activities satisfied roughly similar needs. Proficiency in both golf and photography depends on sensitivity, balance, timing, and precision. In both disciplines successful "shots" are, to some degree, mysterious and unpredictable. Practice and experience significantly increase one's percentage of graceful and accurate shots, but success cannot be forced or taken for granted. Both require an inward focussing of attention, and the ability to simultaneously think and feel one's way through the process. And both activities are deceptively complex; they are easy to do, but exceedingly difficult to do well.

Photography was more to Callahan than simply an alternative form of recreation, however. As other writers have noted, the commitment he made to the medium in 1941, after a workshop by Ansel Adams, resembled nothing so much as a religious conversion. In fact, Callahan had been raised a devout Christian before turning away from the faith as a young man. He notes that an agnostic friend "talked me out of religion, and I wanted something to fill that space."[5] Callahan's comments over the years confirm the importance of faith, spirit, and devotion in his attitude toward photography.

I found photography as a hobby, and then finally realized that it was something I really believed in. I had believed in the hope of believing in something…and photography was it.[6]

[Upon seeing the work of Ansel Adams in 1941] I was just completely freed. I can't explain it; it was almost like somebody getting religion. Totally freed.[7]

[Photography] has a spiritual effect on me, probably because of my early attitude toward religion.[8]

A picture is like a prayer; you're offering a prayer to get something, and in a sense it's like a gift of God because you have practically no control—at least I don't.[9]

It was Ansel Adams's visit to the Detroit Photo Guild in 1941 that focussed and amplified Callahan's nascent enthusiasm for photography. The younger man was struck by the brilliant clarity and precision of Adams's prints, which served as tangible examples of the medium's unique possibilities. Adams emphasized the need to understand the intrinsic potentials of camera, film, and paper, and to work honestly and simply. He talked of the great composers, and of the expressive parallels between music and photography. And he spoke reverently of Alfred Stieglitz as a great artist and heroic champion of fine photography.

Adams also conveyed his belief in the profound link between art and life:

A great photograph is a full expression of what one feels about what is being photographed in the deepest sense, and is, thereby, a true expression of what one feels about life in its entirety. And the expression of what one feels should be set forth in terms of simple devotion to the medium.…I believe in people and in the simple aspects of human life, and in the relation of man to nature. I believe man must be free, both in spirit and society, that he must build strength into himself, affirming the "enormous beauty of the world" and acquiring the confidence to see and express his vision. And I believe in photography as one means of expressing this affirmation, and of achieving an ultimate happiness and faith.[10]

Callahan wholeheartedly accepted these tenets and committed himself to photography as a means of exploring the "simple aspects" of his own life. The session with Adams transformed Callahan from a diligent amateur into a young artist, bursting with ideas and creative energy.

fig. 2 Harry Ca
Eleanor, (

documentary approach based on the examples of Lewis Hine, the Farm Security Administration, and photojournalism. While work of this second type varied considerably in approach, it emphasized the human presence by focusing on faces, gestures, and interactions between individuals. The work of fine photographers such as Morris Engel, John Gutmann, Sid Grossman, Louis Faurer, Dan Weiner, Leon Levinstein, and Helen Levitt expressed this spontaneous and humanistic approach in images that could be confrontational, dynamic or intimate[20] (figure 4). Callahan's pictures, instead, are characterized by their quietude, emotional restraint, and lack of overt narrative.[21] In contrast to much of the work of his contemporaries, Callahan's photographs were not about social issues, political action, dramatic incidents, or particularly "artful" compositions.

Despite their modest and introspective nature Callahan's city photographs embraced a remarkably broad vision of the urban experience. He used his 8 x 10″ camera to record facades and architectural details with great precision. Multiple exposures were made of buildings, street activity and other subjects with a variety of cameras. And with the small 35mm camera Callahan made close-ups and middle-distance images of anonymous pedestrians.

Callahan's photographs of facades were motivated by his interest in both their visual structure and human content. The formal elegance of his view camera work has been widely acknowledged. At the same time, Callahan was attracted to certain buildings by the idiosyncratic traces of their builders and occupants. In the details of brickwork or the gentle rhythm of shades and curtains in a bank of windows, Callahan suggests a pervasive human presence (figure 5). His photographs of exteriors emphasize the architectural facade as the threshold between the public and private realms of experience. Like the people who inhabit them, these urban structures reveal subtle and individual details to acute observers, while holding everything else tightly in reserve.

Multiple exposures intrigued Callahan from the beginning of his work in photography. The reasons for this interest certainly involve the influence of the Bauhaus sensibility as well as Callahan's innate fascination for the transformative power of the multiple image. The simple process of exposing two or more

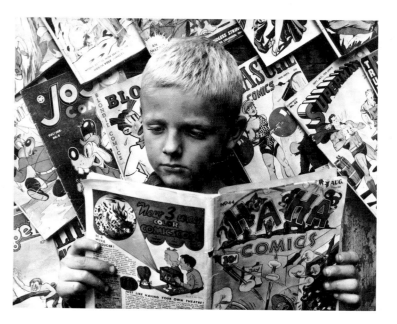

fig. 4 Morris Engel
Comic Book Stand, New York, ca. early 1940s

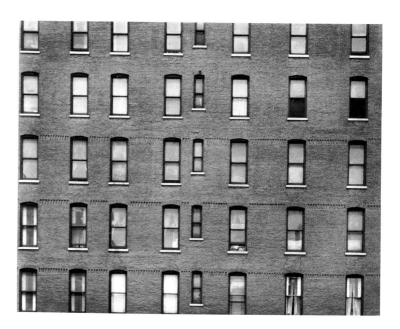

fig. 5 Harry Callahan
Chicago, ca. 1949

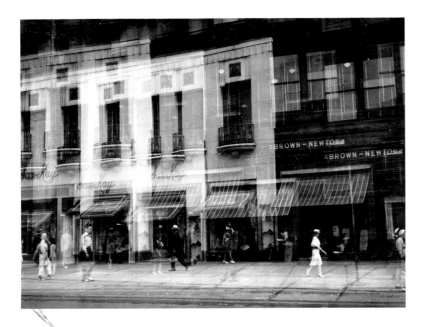

fig. 6 Harry Callahan
 Detroit, ca. 1942

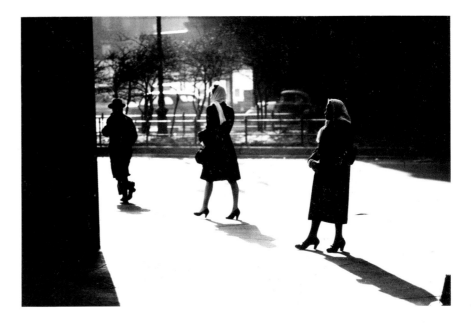

fig. 7 Harry Callahan
 New York, ca. 1945

scenes on a single negative results in a multitude of unforeseen visual effects. Overlapping images create a new pictorial product that is both the sum of its constituent parts and something radically new. The multiple exposure uses a mechanical vision for surrealistic effect; by interweaving discrete visions the multiple seems to fold reality back on itself, or to shatter it into stuttering fragments (figure 6). It replaces a straight photographic vision of solidity and permanence with one of transparency, instability, and weightlessness. Multiple exposures cancel the insistent referentiality of the single image to produce a synthetic, clearly two-dimensional representation.

From a philosophic and aesthetic point of view the multiple presented an appropriate and ingenious means to express the energy and impermanence of the modern city. In *Civilization and Its Discontents* (1930) Freud proposed a vision of Rome that parallels the effect of the photographic multiple exposure. Freud asked his readers to imagine that, wherever they looked in contemporary Rome, they would simultaneously see both the existing structures and all the earlier buildings that had ever occupied these spaces.[22] By evoking this

superimposition of spatial forms, Freud suggested an analogy for the nature of the human mind. He also expressed an important current of the modern urban sensibility. As Burton Pike has written, "the Renaissance ideal of the city is presented in terms of fixed spatial relationships embodying an ideal cosmic order; the dynamic modern city is presented in terms of action in time" and by spatial transformation.[23] Callahan's multiple images convey this sense of the city as an arena of flux and change. They also seem remarkably successful in creating an "equivalent" for the city's nervous motion and noise in still, two-dimensional form.

Callahan's photographs of pedestrians convey a characteristic set of themes. He had quickly grown dissatisfied by the literal value of his earliest city photographs, which focussed on such "recognizable action" as people talking or laughing together. Instead, he became fascinated by people walking, "lost in thought"[24] (figure 7). Callahan was captivated by the visual rhythms of people walking, the spaces carefully preserved between them, and the linear and graphic effects of light and shadow. Callahan's city dwellers are typically pictured in

fig. 8 Harry Callahan
Chicago, 1950

motion, proceeding in orderly fashion from one unspecified place to another. With eyes fixed squarely ahead, they remain individually isolated in the midst of their unacknowledged companions.

Rather than simply indicting the modern city, these images suggest the tension between two interpretations of contemporary urban life. When Yeats spoke of an age as "a stream of souls," he found a mythic beauty in the press and flow of humanity. For him, "every soul is unique…[and] these souls, these eternal archetypes, combine into greater units as days and nights into months, months into years, and at last into the final unit that differs in nothing from that which they were at the beginning." Life, for Yeats, was a cyclical process of growth in which "in the course of one life and many lives, our individuality frees itself from, then returns to, a communal matrix."[25]

Yeats's idea of mythic wholeness stands in contrast to the notions of individual alienation, meaninglessness, and absurdity articulated by other modern writers. The nameless, faceless characters of T. S. Eliot's *The Wasteland*, for example, lead lives of mechanical emptiness. The playwright Samuel Beckett

created visions of deadened, paralyzed people incapable of memory or meaningful action. These and other images of individual and cultural sterility recall words spoken by a character in Ford Madox Ford's *The Good Soldier* (1915): "I thought of nothing; absolutely nothing…I felt no sorrow, no desire for action.…I was the walking dead."[26]

Callahan's photographs of the 1940s and 1950s accomplish the formidable task of reconciling Yeats's mystical optimism with Beckett's alienated despair. Callahan has consistently portrayed the impersonality and oppressive scale of the city. His pictures evoke Hawthorne's description of the street as "a paved solitude between lofty edifices" while suggesting a pervasive aesthetic mood of the period.[27] They become equivalents for "the lonely crowd" of David Riesman's influential 1950 sociological text, while underscoring the literary presumption of the era that "the art of fiction making demands a solitary sensibility speaking to another solitary sensibility."[28] It has been suggested, for example, that the appeal of the fictional American detective of the 1940s and 1950s was "due less to the interest in crime or in puzzle solving, than to the feeling that another America of family and friends and trust between strangers has been lost and that the only guardians of its empty treasury are these tender, armored professionals of loneliness."[29] Callahan's photographs convey a sense of both this protective armor and of our fragile, underlying tenderness. He realized that loneliness itself was a fundamental aspect of the human condition and thus, paradoxically, evidence of our links to one another. As Thomas Wolfe wrote in *Of Time and The River* (1935), "we walk the streets, we walk the streets forever, we walk the streets of life alone."[30] (figures 8, 9). Walking the streets alone came to symbolize both individual solitude and a modern form of universal kinship.

It seems significant that a majority of the pedestrians recorded by Callahan were women. His shyness may have drawn him to photograph persons who seemed equally reserved and therefore unlikely to confront or challenge him. On a deeper level this artistic predilection suggests an integral aspect of Callahan's vision. For example, Sherman Paul wrote in 1967 that Callahan "seeks to redress the frightening masculinity of our culture" in order to discover

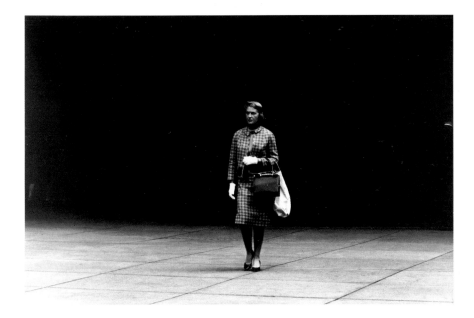

fig. 9 Harry Callahan
New York, 1962

"the intimate spaces of life."[31] A. D. Coleman, in 1980, posited that women are "the symbol of humanization for Callahan," and that "the true underlying issue" in Callahan's work has been his effort to come "to terms with the feminine mode of perception as an aspect of self." In this context, intimacy, intuition, and nurturing may be understood as prototypical "feminine" attributes. Coleman observes that the central idea in Callahan's life has been "the imperative of nurturing" a marriage, a family, hundreds of students, and a full and meaningful body of work.[32]

Callahan's focus on urban women emphasizes the poignance of modern city life. It has been argued that women symbolize the concepts of sustenance, stability, and community in contrast to the "masculine" attributes of power, economic production, and mobility. It has also been observed that early twentieth-century women authors tended to perceive the city differently from their male counterparts of the same period; "in Chicago women's novels generally, the city is linked to the country in a society that centers on families, both biological and figurative."[33] Male authors, on the other hand, tended to view the city more abstractly, as a realm of conflict and individual achievement. Callahan's photographs of silent, solitary women suggest in rigorously unsentimental terms both the human cost of an overly "masculine" society and the durability and promise of the "feminine" aspects of life. Given his own artistic sensibility and disinterest in business or financial achievement, it is appropriate that Callahan felt a deep sympathy for, and identity with, these anonymous women pedestrians.

The ceaseless activity of the street presented perceptive artists with new visions of time and timelessness. In "Memorial for the City" (1949) W. H. Auden decried the barrenness of the modern secular city. He expressed the feeling that "the world as it appears to animals or cameras is one in which time is the enemy and human events are without significance."[34] Auden saw little hope for transcendent, life-sustaining dreams in a world ruled by cold rationality. He also seems to have considered the camera capable only of an amoral and mechanical vision.

The uses of the camera to convey some sense of time and human significance may be suggested by comparing photographs by Else Thalemann (ca. 1930) and Callahan (1961) (figures 10, 11). Both images reflect the spontaneous and candid vision of the 35mm camera, and both picture anonymous pedestrians beneath looming clock faces. The Thalemann is a gritty, oblique vision of a shadowy world populated by depersonalized beings and ordered by the inflexible precision of the clock. This image recalls the oppressive mood of Fritz Lang's great silent film *Metropolis* (1926).

The Callahan photograph, while superficially similar to the earlier work by Thalemann (which he almost certainly never saw), deals with these themes in a different manner. Callahan's pellucid image is divided vertically between darkness and open sky. It is 12:32 p.m. on a sunny afternoon and the streets are full of noontime activity. Shoppers swarm the sidewalk beneath a vaguely animate street light that reaches in all directions. Callahan's low vantage point and wide-angle lens lend the looming foreground figure a curious sense of both proximity and distance. Her dramatic "pose" suggests the majestic stasis of a classical statue. The woman thus becomes both banal and heroic, mortal and

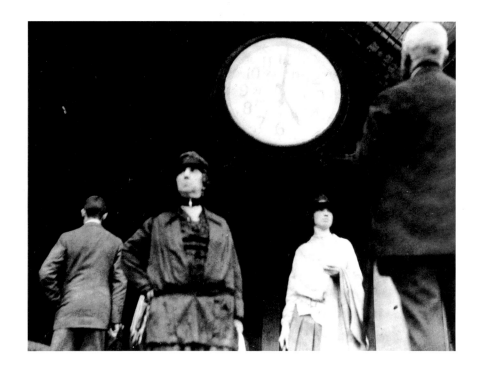

fig. 10 Else Thalemann
Warten auf den Zug, ca. 1930

larger than life as the momentary and the timeless are conflated to suggest the mystery of the everyday.

Related to the idea of time are the themes of chance and randomness. For many artists, the street became the stage for an endless series of juxtapositions and compositions produced by a continuous Brownian movement of humanity. This odd ballet of the street suggested life's underlying strangeness and the inadequacy of conventional narrative expectations. There was an almost hypnotic fascination in the street's effortless unfolding of an infinite number of figural permutations and combinations. This vision of randomness suggested that unrepeatable "compositions" were hidden in every fleeting moment.

Callahan was fascinated by the random energy of the street (figure 12). It is not surprising, then, that he appreciated the work of other artists, such as Balthus, who also explored these themes (figure 13). Balthus's pedestrians share with Callahan's a physical proximity, emotional distance, and individual self-

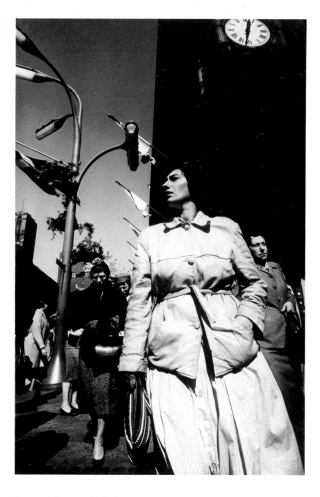

fig. 11 Harry Callahan
Chicago, 1961

exclusively with color at this time. The great majority of artistic photographers felt that only monochromatic materials were suitable for artistic purposes.

The reasons for this bias against color included the problem of presentation. While beautiful in themselves, color slides did not allow for the easy creation of prints, and it was only in print form that images could be seriously studied, exhibited, and collected. Printing color images by the dye-transfer process was technically demanding and exceedingly expensive.[45] Other, simpler color processes tended to produce prints of mediocre quality and uncertain permanence. Thus, after two decades of intermittent use, Callahan gave up color photography in 1964 due to the lack of critical interest generated by this work, and his frustration over the limitations of the slide format.

However, this early interest in color paved the way for Callahan's complete conversion to the medium in 1977. By that time several important changes had taken place that made color newly attractive and practical. The critical bias against the medium was gone by the mid-1970s, and a growing number of leading photographers such as William Eggleston, John Pfahl, Joel Meyerowitz, and Stephen Shore were celebrated for their work in color. In addition to this new art world acceptance, the production of color prints had become much easier. Photographers now routinely made their own "type-C" prints from color negatives, or printed from slides by the Cibachrome process.

This new artistic interest in color coincided with a swelling popular enthusiasm for the art of photography. During the "photography boom" of the mid-1970s museums and private collectors began acquiring fine photographs in increasing numbers, and new galleries opened to sell the work of historical and contemporary artists. Callahan benefitted from this new interest in collecting, and his black-and-white prints sold at a pace that would have been inconceivable a decade earlier.

The new market value of Callahan's work allowed him to utilize color print processes that had been previously unaffordable. For reasons of both permanence and chromatic range, Callahan had always preferred the dye-transfer process. Now, the ability to have dye transfers made by a professional lab, subject to his approval, allowed the creation of high-quality color prints. It also freed Callahan completely from the mechanics of the darkroom. As Sally Stein has observed,

> the sudden willingness to consign to a lab the work which previously distinguished the fine-art photographer suggests not only a new degree of self-assurance on Callahan's part but a desire to simplify the idea of photographic work and to locate its significance wholly at the moment of perception.[46]

Callahan's pleasure in this new arrangement only increased in 1981 when he first had prints made by the West German firm of Gundlach. By using a laser scanner to make printing separations directly from the original transparencies, Gundlach's dye transfers displayed more accurate colors and a remarkable image sharpness. On first seeing these new prints Callahan was reminded of his enthusiasm in 1941 for the print quality of Ansel Adams's work. Adams's prints "were very delicate and sharp...and I felt the same way when I saw the prints from Gundlach."[47]

The plates in this book represent the major themes of Callahan's work since his "rediscovery" of color a decade ago. A number of thematic continuities are apparent between these recent photographs and his earlier body of black-and-white city pictures. For example, his interest in the random patterns of street activity is seen in photographs from Egypt (pp. 29-31), Morocco (pp. 56-57) and Mexico (p. 65). Callahan's fascination for isolated people lost in thought has also endured, as witnessed in photographs from Ireland (p. 37), Morocco (pp. 43, 52, 55), Mexico (p. 61), Portugal (p. 73), Atlanta (p. 99) and elsewhere. His continued interest in starkly simple compositions (pp. 43, 47), wide-angle lenses (p. 83), and the expressivity of architectural facades (pp. 61-63, 76-81) is also clear. In several instances there are startling similarities between these new photographs and Callahan's "classic" images. Plate 99, for example, is structurally identical to the 1950 image reproduced as figure 8. Together these photographs document Callahan's endless fascination with specific pictorial ideas, as well as changes in women's fashions over thirty-five years' time.

Other, more subtle themes recur in this new work, such as the contrast between the descriptive clarity of sunlight and the graphic mystery of shadows.

In a number of these recent images (for example pages, 2, 48, 65, 69, 82, and 97) deliberate use is made of deeply shadowed areas for both formal and emotional effect. An ominous sense of mortality, for instance, seems to underlie Callahan's image (p. 113) of a man striding into a jagged and opaque shadow. An equally unobvious motif involves the tension between flatness and depth, walls and apertures. In a number of photographs (e.g., pp. 1, 30-33, 48, 55, 59, 62-63) Callahan creates a frontal, planar image that displays visual data within an extremely shallow pictorial field. In other images (e.g., pp. 41, 44-45, 49, 71-72, 83) he emphasizes a sense of depth by contrasting partial closure with a potentially infinite spatial recession. These motifs suggest the themes of place and space, confinement and movement.

While these and other earlier themes recur in this recent work, Callahan's use of color adds an important new aspect to his vision. Color allowed Callahan to rediscover familiar subjects; the same streets and buildings he had photographed for years in black and white now presented new artistic possibilities. On another level, color itself became Callahan's subject, as chromatic concerns became as important as graphic relationships in the process of picture making.

Callahan's move from the reductive purity of black and white to the lush and expansive palette of color signalled his openness to the new chromatic "reality" of contemporary life. Callahan has stated repeatedly that his interest in color was stimulated by its pervasive presence in magazines and on billboards and television. In this color-flooded world, black-and-white images run the risk of seeming quaint or antique. From this perspective it is clear that the aesthetic of our time—in all its subtlety or garishness—is embodied most authentically in color imagery.

Color also added a different kind of lyricism and visual pleasure to Callahan's work. In contrast to the restrained elegance of his black-and-white prints, Callahan's dye transfers convey a mood of warmth and liveliness. The varied hues of these prints make them more immediately appealing to some viewers than his earlier black-and-white photographs. While purists may prefer the reticence of his monochromatic work, it is clear that Callahan's current feelings about photography and himself are reflected in the vibrance of these colors.

The themes of travel and domesticity are intertwined in these recent pictures. After his retirement from teaching in 1977, Callahan had both the time and resources to travel as he wished. Since then the artist and his wife have made a number of trips, to Europe, North Africa, and the Far East, that combine sightseeing with photography. But while he enjoys traveling, Callahan also came to appreciate his familiar haunts once again. In the last few years a greater proportion of Callahan's images has been made in his home cities of Providence and (since late 1983) Atlanta, or in New York, which he has visited for decades. And it is clear that even in foreign locales Callahan avoids overly "exotic" subjects in favor of the relatively ordinary or domestic aspects of life. While he is intrigued by the experience of different cultures, Callahan seems to feel that all places are equally rich in human meaning and artistic potential.

Callahan's formal control—his ability both to record and create his subjects—is demonstrated in his views of Ireland. Callahan's wide-angle lens stretches and flattens a quiet street scene (p. 35) into a set of interlocking vectors and planes. Another photograph (p. 37) combines a plunging perspective with a curious sense of vertical scission, as if two different views were joined at the central line of wires, telephone pole, and curb. Callahan's ability to shape pictorial space is seen in the sequence of plates reproduced on pages 37-41. Here his precise choice of vantage points within a very limited area creates a remarkably varied set of images.[48]

Callahan has always been able to generate picture ideas from the simplest subject matter. His attention to subtle details and willingness to photograph freely often result in more than one successful image from a single basic motif. The pairs of images reproduced on pages 56-57, 94-95, and 106-107 represent three such instances. Callahan's photographs of a Moroccan marketplace (pp. 56-57) differ by only a few seconds of real time, but suggest a potentially endless stream of visual incident. The multiples on pages 94-95 present slightly variant views of the same buildings and sidewalk. On page 94 a minor change in perspective allows the humorous and serendipitous overlap of a background building and two walkers. And finally, on pages 106-107, we see video multiples combined with very different views of Atlanta. Both succeed owing to Callahan's

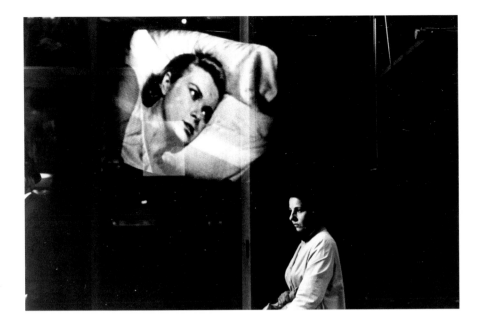

fig. 15 Harry Callahan
 Providence, 1967

deliberate use of shadow and the complex relationships between the video and urban images. These pairs of photographs remind us of the multiplicity of visual experience and the range of pictorial possibilities in any subject.

It is perhaps in his multiple exposures that Callahan most clearly "creates" his subjects. These recent multiples blend images with an audacious sense of spontaneity and complexity. Callahan's renewed interest in multiple imagery was stimulated, in part, by a visit to a student art exhibition in Atlanta. A fellow viewer commented that the paintings, though largely unresolved, had a raw and refreshing energy. The discordant vitality of the work also impressed Callahan, and he decided to make "messy" images of his own: "I went out and just put as many things together as I could."

His process of making multiple exposures—running the film through the camera twice—precludes any precise and deliberate juxtaposition of images. Callahan chooses what to record during both sets of exposures, but the final combination of views is always, to some degree, unforeseen. Many of the resultant images are, of course, failures. An additional number contain fascinating passages that suggest future choices of subject matter. Finally, a select few are deemed successful for the quality and vitality of their layered effects. While "messiness" may have been an original motivation for these images, Callahan laughingly admits that he always ends up "choosing the ones that really aren't messy"; that is, the images that balance chaos and coherence, and which are both a revelation and a confirmation.

Callahan's multiples reveal a broad variety of visual effects. Some of the most complex of these photographs (pp.86-89) compress space to create a dense fabric of figures, buildings, signs, and vehicles. The eye struggles to resolve these tightly layered scenes into their constituent parts, and to create figure/ground relationships from the commingled images. In other, structurally simpler views (pp. 85, 91, 94-95), a clear central motif serves as a focus for the picture's dynamism. On page 85, an eloquent comment on fashion and function, a chic mannequin and a noted example of avant-garde architecture (Philip Johnson's AT & T building) are juxtaposed with an elderly pedestrian and mundane brick structure. On page 91 the random kinetic and chromatic energy of the street is fixed at the center of an architectonic pinwheel. And on page 93 discrete scenes blend imperceptibly to create a subtle and surreal vision of transparency.

Callahan's television multiples grew out of his long familiarity with the electronic medium. The Callahans acquired their first set shortly after their daughter was born in 1950. They had difficulty finding babysitters and so would stay at home to watch television. Callahan's black-and-white video multiples of 1966-67 evoke the omnipresence and hypnotic allure of the medium. They also suggest curious connections between the electronic images and figures on the sidewalks of Providence. In figure 15 a soap opera character and an anonymous pedestrian are both pictured lost in thought. Their mutual state of dreamy introspection suggests that one is the visualization of the other's reverie or that they are complimentary aspects of a single sensibility.

Callahan's recent video multiples extend the complexities of this earlier work. Fascinated by the artificiality of the color video image, Callahan emphasizes its ephemerality and abstraction. He often deliberately distorts the

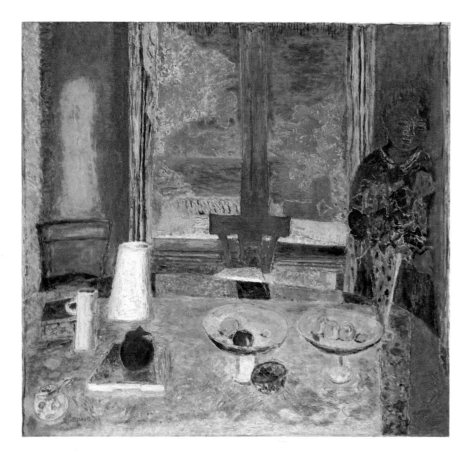

fig. 16 Pierre Bonnard
Dining Room on the Garden, 1934
oil on canvas, 50 x 53⅜″
Solomon R. Guggenheim Museum, New York
(Photo: Carmelo Guadagno)

color balance and image registration of his television to enhance the garish weirdness of the image. In the resultant multiples, indecipherable messages (p. 105) and jarringly unreal faces (p. 109) crowd into the spaces of the "real" world. The medium, full of static and nonsense, becomes the message. And it seems valid to suggest that the powerful seduction of television itself underlies Callahan's images of a sultry colossus lurking in the city's shadows (pp. 106-107).

A very different aspect of Callahan's meditation on images is seen in a multiple exposure (p. 110) combining a landscape and a book on the painter Pierre Bonnard, opened to a reproduction of Bonnard's work *Dining Room on the Garden* (figure 16). Callahan uses his art to pay homage to Bonnard's, and it is a particularly felicitous choice. Numerous similarities between the two men could be suggested, including the particular mix of melancholy, tenderness, and introspection contained in their respective bodies of work. In a direct parallel to Callahan, it has been noted that Bonnard's "favorite amusement was walking; from his daily walks in Normandy or in the Provencal countryside he returned with his pockets stuffed with sketches."[49] While Bonnard was criticized for his casualness and offhanded spontaneity, in fact "his nonchalance is strongly calculated and his liberties have their laws."[50] It can be surmised that Callahan admires Bonnard's paintings for both their chromatic logic and their loving domesticity.[51] Bonnard felt that the "infinitely humdrum, the infinitely close…constitute the ultimate riddle."[52] And in his late work Bonnard used color "with a surprising boldness and freedom"[53]; he sought

> to see clearly and directly, to see everything, and to aim straight….It was that particular directness that allowed Bonnard so glorious a freedom in the work of his last years….Bonnard looked at the world as if no one had ever seen it before, and he found a new name for everything he saw.[54]

Bonnard's painted image of nourishment and repose becomes for Callahan a source of aesthetic sustenance. Callahan's image gently *re*presents Bonnard's work in order to evoke its spirit, and the mood of this homage suggests the photographer's intuitive understanding of the painter's achievement. "Bonnard seems to approach objects almost shyly, exploring them one by one, lingering

over even the most modest of them, in no way disturbing what chance has brought together under the light....The composition gives the impression of total freedom and exquisite naturalness."[55] Callahan's photograph and the Bonnard painting both establish a subtle counterpoint between interior and exterior, still life and view. Callahan's inclusion of a large fragment of the book's textual commentary reinforces the fact that we are looking at a synthesis of nature and image. The reproduced text yields phrases and fragments rather than complete sentences: "...something unstable, fleeting...delectation of the senses...the light coming into the room and the colors...these in turn reverberate...interior and landscape, the crux of the problem...accentuating the disjunction...the grand luminous accord..."[56] These passages seem perfectly descriptive of Callahan's own image, which is intuitive, slightly askew, and yet perfectly resolved.

Callahan's photograph records enough of the original text to convey a general sense of scholarly interpretation. However, the missing passages frustrate any attempt at purely logical thought. We are forced to substitute words for those that are lacking and thus to construct our own explanation: an interpretive act initiated by Callahan's own interpretation of this earlier analysis. His subtle photograph utilizes spontaneity and serendipity to suggest a complex melding of nature and culture, past and present, thought and sensation. It also reminds us that reading is only one way to understand the world through our eyes and that *seeing* is every bit as important.

The liberating and transformative power of vision lies at the heart of Callahan's process. Far more complex than they superficially seem, his photographs are about such "simple" attributes as an openness to chance and change, trust of intuition, and respect for the lessons of trial and error. In the tradition of American pragmatism, Callahan embraces experimentation while valuing tangible results over disembodied concepts. A basic strength of his work may be that it does not attempt an artificial, theoretical "purity" and consequently has a life that extends beyond the scope of words.

These recent pictures constitute an important and logical addition to Callahan's celebrated oeuvre. Here we see both subtle and bold variations on well known themes, as well as images that may be entirely unexpected. Artistic energy and risk-taking combine with thematic continuity to enlarge and deepen our understanding of Callahan's creative vision. In addition to the themes discussed in the preceeding pages, these photographs suggest Callahan's balance of tradition and freedom, concepts which mark the conceptual poles of his art.

Tradition means several things to Callahan. Cognizant of the achievement of earlier photographers and artists, he is aware of building on an existing artistic legacy. Callahan's work both derives from and contributes to that history of artistic thought, and this sense of belonging is of value to him. Callahan is also fascinated by the larger creative realm represented by crafts, vernacular architecture, and other expressive aspects of everyday life.[57] He deeply respects the skills and insights that are passed from generation to generation, as well as the unschooled creativity expressed in such things as the design and coloration of simple residences. And, as tradition implies communication and human continuity, Callahan is aware of the importance of an audience. As he quietly states, it has always "meant a lot" that his work speaks to others: "I like to move other people."

Personal freedom is also central to Callahan's art. He has always felt the need to work at his own pace, in his own way, with little obvious concern for what others may do. Photography, as a basically solitary activity, allowed Callahan to withdraw into himself in order to make sense of the world around him. Callahan's artistic life represents a continuous attempt to recreate his original excitement of discovery: "I felt very strongly that Ansel Adams freed me, and I want to repeat that over and over."[58] That original freedom constituted nothing less than a new way of life. Callahan's art gave him the ability to create objects of meaning and beauty, communicate his feelings to others, and engage in a powerful, spiritually fulfilling quest.

This freedom is inevitably modern, and thus problematic. Callahan's freedom is the ironic result of desire, compulsion, and slavish commitment; it is the freedom to work and struggle with no hope of a definite solution or conclusion. The search itself, with all its frustrations, failures, and insecurities, becomes of supreme importance.

Callahan's great gifts include his ability to cast life's beauty and instability into memorable visual form, and to synthesize seemingly irreconcilable dichotomies. His simple, unemotional, and nonverbal approach results in a body of work that is complexly meaningful, deeply moving, and eloquently expressive. And his self-expressed lack of control over the artistic process in fact represents a profound understanding of the value of chance and accident. Callahan's artistic will is expressed in his union with both the medium of photography and the world around him, rather than in any desire to forcibly shape either to match preexisting concepts. Callahan reveres the hard reality of each, and this respect has been abundantly rewarded.

FOOTNOTES

1. Unless otherwise noted, quotes by the artist are from interviews conducted with the author in 1987.

2. Many of these biographies and interviews are listed in this volume's bibliography; note in particular the lengthy reminiscence in the 1981 Hallmark catalog. Also highly recommended are three volumes published prior to the period surveyed in our bibliography: *Photographs: Harry Callahan* (Santa Barbara: El Mochuelo Gallery, 1964); *Harry Callahan*, with essay by Sherman Paul (New York: Museum of Modern Art, 1967); and John Szarkowski, *Callahan* (New York: Museum of Modern Art, 1976).

3. Callahan attended Michigan State University from the fall term of 1934 through winter term, 1936. He first majored in chemical engineering and switched to business during the fall 1935 term. See Thomas Gladysz, "Harry Callahan's Personal Vision," *Michigan State News*, October 1, 1984.

4. Joe Munroe, "Harry Callahan," *Infinity*, January 1969, p. 18.

5. Jain Kelly, ed., *Nude Theory* (New York: Lustrum Press, 1979), p. 29.

6. Barbaralee Diamonstein, *Vision and Images: American Photographers on Photography* (New York: Rizzoli, 1981), p. 15.

7. Gladysz, n.p.

8. Diamonstein, p. 15.

9. A. D. Coleman, "Harry Callahan: An Interview," *Creative Camera International Year Book 1977* (London: Coo Press, Ltd., 1976), p. 76.

10. Ansel Adams, "A Personal Credo," originally published in *American Annual of Photography*, vol. 58 (1944), pp. 7-16; reprinted in Nathan Lyons, ed., *Photographers on Photography* (Englewood Cliffs, N.J.: Prentice-Hall, 1966), pp. 25-31.

11. Jacqueline Brody, "Harry Callahan: Questions," *The Print Collector's Newsletter*, January/February 1977, p. 173.

12. Charles Hagen, "Late Color," *Camera Arts*, July 1983, p. 76.

13. John Szarkowski has written that in the early 1940s Callahan and Webb "formed their image of the artist's life by reading Somerset Maugham's *The Moon and Sixpence*, in which a fictionalized version of Gauguin epitomized the role of the artist as a lonely hero, by definition beyond the understanding of his fellows." *Callahan* (1976), pp. 16-17. Callahan recalled later that in those early years he and Webb felt that they "were going to be just like Van Gogh and never be recognized and just do this great stuff." Keith F. Davis, *Harry Callahan: Photographs* (Kansas City: Hallmark Cards, 1981), p. 53.

14. John Grimes, "Arthur Siegel: A Short Critical Biography," *Exposure* 17:2, pp. 22-24.

15. For a useful overview of Moholy's teaching and the resultant pedagogical climate at the Institute of Design, see Charles Traub, ed., *The New Vision: Forty Years of Photography at the Institute of Design* (Millerton: Aperture Issue No. 87, 1980).

16. Cited in S. P. Karr, "The Third Eye," *Art Photography* (Chicago), September 1952, p. 34.

17. *Harry Callahan and His Students: A Study in Influence* (Atlanta: Georgia State University, 1983), n.p.

18. Elayne H. Varian, *Hugo Weber: A Retrospective Exhibition* (New York: Finch College, 1975), n.p.

19. Burton Pike, *The Image of the City in Modern Literature* (Princeton: Princeton University Press, 1981), p. 3; Lewis Mumford, *The City in History* (New York: Harcourt, Brace and World, 1961), pp. 30-31.

20. The urban pictures of these and other photographers were reproduced in *U.S. Camera Annuals* of the period. For example, see Morris Engel (1941, vol. I, pp. 141-48), John Gutmann (1941, vol. II, p. 117), Sid Grossman (1950, pp. 252-53), Louis Faurer (1950, pp. 186-87), and Leon Levinstein (1956, pp. 262-67). Helen Levitt's brilliant work of the early 1940s has been reproduced in her book *A Way of Seeing* (1965). See also *Todd Webb: Photographs of New York and Paris, 1945-1960* (Kansas City: Hallmark Cards, 1986) for a summary of the early urban photographs of this close friend of Callahan.

21. For example, see Callahan's published portfolios in the *U.S. Camera Annuals* for 1951 (p. 294) and 1952 (p. 132). Reproduced in intimate scale, Callahan's photographs are simple and undramatic in comparison with work by other photographers.

22. Sigmund Freud, *Civilization and Its Discontents*, trans. James Strachey (New York: W. W. Norton, 1961; first published 1930), p. 17.

23. Burton Pike, p. 139.

24. See Callahan's statement in *Photographs: Harry Callahan* (Santa Barbara: El Mochuelo Gallery, 1964), n.p.

25. Robert Langbaum, *The Mysteries of Identity: A Theme in Modern Literature* (Chicago: University of Chicago Press, 1982; originally published 1977), p. 150.

26. Ibid., p. 17.

27. This phrase from Hawthorne's "The Gray Champion" serves as a central metaphor in Pike.

28. Leo Braudy, "Realists, Naturalists, and Novelists of Manners," *Harvard Guide to Contemporary American Writing*, ed., Daniel Hoffman (Cambridge: The Belknap Press, 1979), p. 133.

29. Ibid., p. 103. In his *Hardboiled America: The Lurid Years of Paperbacks* (New York: Van Nostrand Reinhold, 1981), Geoffrey O'Brien observes that what Raymond Chandler's "Marlowe novels are finally about is simply loneliness in a sprawling city void of spiritual comforts" (p. 78). He later stresses that "the hardboiled novel—which is meant to be concerned with action, with dialogue, with the complicated and dynamic interrelationship of people and places and times of day...tends in fact toward a zero state of silence, solitude and immobility" (p. 110).

30. Thomas Wolfe, *Of Time And The River* (New York: Charles Scribner's Sons, 1935), p. 155.

31. Sherman Paul (1967), p. 10.

32. A. D. Coleman, "Beating the Reality: Harry Callahan's Color Photography," in *Harry Callahan: Color 1941-1980* (Providence: Matrix Publications, 1980), n.p.

33. Sidney H. Bremer, "Willa Cather's Lost Chicago Sisters," in *Women Writers and the City*, ed. Susan Merrill Squier (Knoxville: University of Tennessee Press, 1984), p. 215.

34. Monroe K. Spears, *Dionysus and the City: Modernism in Twentieth-Century Poetry* (New York: Oxford University Press, 1970), p. 83.

35. Callahan's darkroom wall is decorated with a great variety of images, most in the form of postcards and exhibition announcements. Among the artists represented are Van Gogh, Modigliani, Bonnard, El Greco, Goya, Titian, Bosch, as well as photographers such as Man Ray, Steichen, Brandt, and Callahan himself. At the time it was viewed by the author (July 1987) this wall included reproductions of three Balthus paintings: *The Street*, 1933 (Museum of Modern Art), and *The Mountain*, 1937 and *Figure in Front of a Mantel*, 1955 (both Metropolitan Museum of Art).

36. James Dougherty, *The Fivesquare City: The City in the Religious Imagination* (Notre Dame: University of Notre Dame Press, 1980), p. 98.

37. Ibid., pp. 98, 99.

38. John Grimes, pp. 30-31.

39. John Grimes, essay in *Arthur Siegel: Retrospective* (Chicago: Edwynn Houk Gallery, 1982), n.p. For a contemporary portfolio of Siegel's color work, see "Modern Art by a Photographer," *Life*, November 20, 1950, pp. 78-84. A broader sampling of Siegel's color photographs may be seen in "Arthur Siegel," *Camera* (Lucerne) February 1978, pp. 14-23.

40. Charles Baudelaire, *The Painter of Modern Life and Other Essays*, translated and edited by Jonathan Mayne (New York: DaCapo Press, 1986; first published by Phaidon Press, 1964), p. 9.

41. Charles Baudelaire, *Oeuvres completes* (Paris: Editions Gallimard, Bibliothèque de la Pleiade, 1961), pp. 243-44; cited in Pike, p. 25.

42. Harry Callahan, *Water's Edge* (Lyme, Connecticut: Callaway Editions, 1980), n.p.

43. Actually, it is likely that Callahan regretted his own inability, due to shyness, to make contact with strangers. In his teaching at the Institute of Design Callahan recalls that he "introduced problems like 'evidence of man', and talking to people—making portraits on the street. Talking to people nearly killed some students, but I thought they should enter into dealings with human beings and leave abstract photography." Cited in Charles Traub, "Photographic Education Comes of Age," *The New Vision*, p. 45.

44. Richard Sennett, *The Fall of Public Man* (New York: Vintage Books, 1978), p. 27.

45. Callahan recalls that in the early 1950s, when he earned a salary of $4,000 annually, it cost $150 to have a single dye-transfer print made (see Diamonstein interview, p. 21). John Grimes's comment (Houk Gallery catalog, n.p.) on Arthur Siegel's difficulty in making dye-transfer prints is also instructive:

> Instead of exhibitions and publications, Siegel went on lecture tours showing his work in slide form. When he finally had cause to print his work for a one-man show at the Art Institute of Chicago in 1954, he was constrained to choose a very few images and to represent the variety of his work more than its depth. It took him years to pay off the debts he incurred in producing these prints and he never had another group of dyes made. As an unfortunate consequence, large portions of his work exist in slide form only.

46. Sally Stein, *Harry Callahan: Photographs in Color, The Years 1946-1978* (Tucson: Center for Creative Photography, 1980), p. 30.

47. Charles Hagen, p. 72.

48. Plates 37, 38, and 39 were all taken within a distance of about forty yards. Plate 41 looks back down the alleyway pictured in the center of plate 39, toward this latter camera position.

49. Andre Fermigier, *Pierre Bonnard* (New York: Harry N. Abrams 1969), p. 32.

50. Ibid., p. 39.

51. Bonnard postcards on Callahan's darkroom wall include *The Terrace at Vernon*, 1919 (Metropolitan Museum of Art), and *La Toilette*, 1914 (Musée National d'Art Modern, Paris).

52. Sasha M. Newman, *Bonnard: The Late Paintings* (London: Thames and Hudson, 1984), p. 32.

53. Fermigier, p. 39.

54. Newman, p. 10.

55. Fermigier, p. 140.

56. Ibid.

57. In July 1987 Callahan was particularly excited by his recent purchase of a beautiful hand-woven egg basket made by a Kentucky craftsman. The basket had been assembled from carefully shaped strips of wood without staples or nails.

58. *Harry Callahan: Photographs* (1981), p. 55.

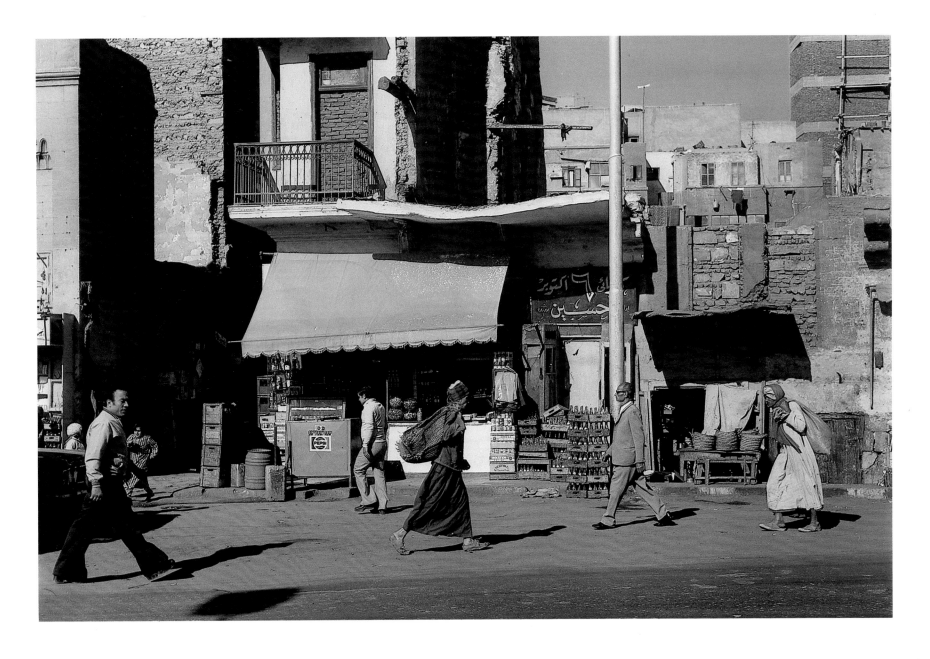

Egypt, 1978

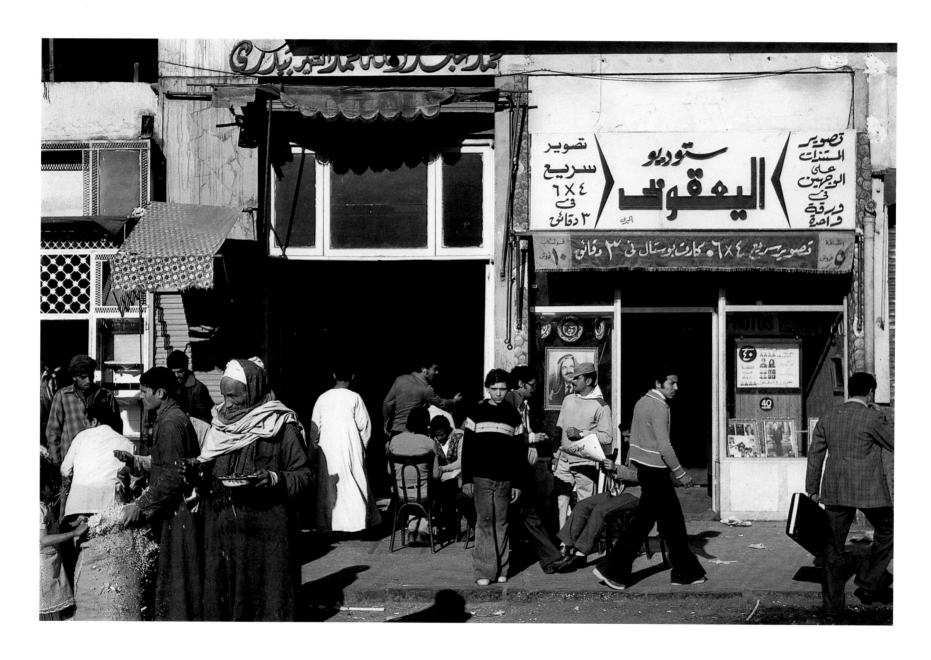

Egypt, 1978

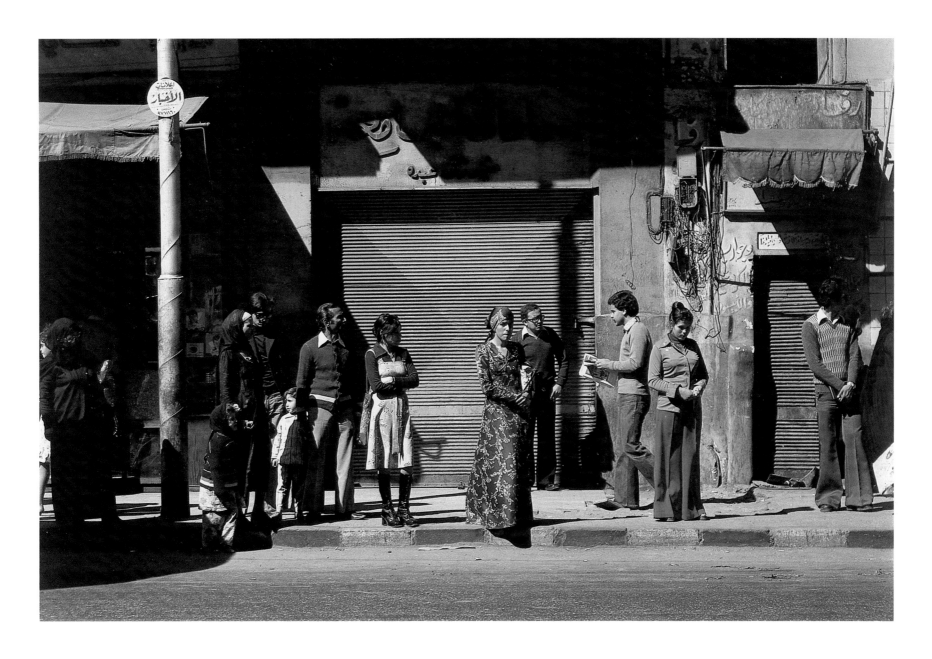

Egypt, 1978

31

Egypt, 1978

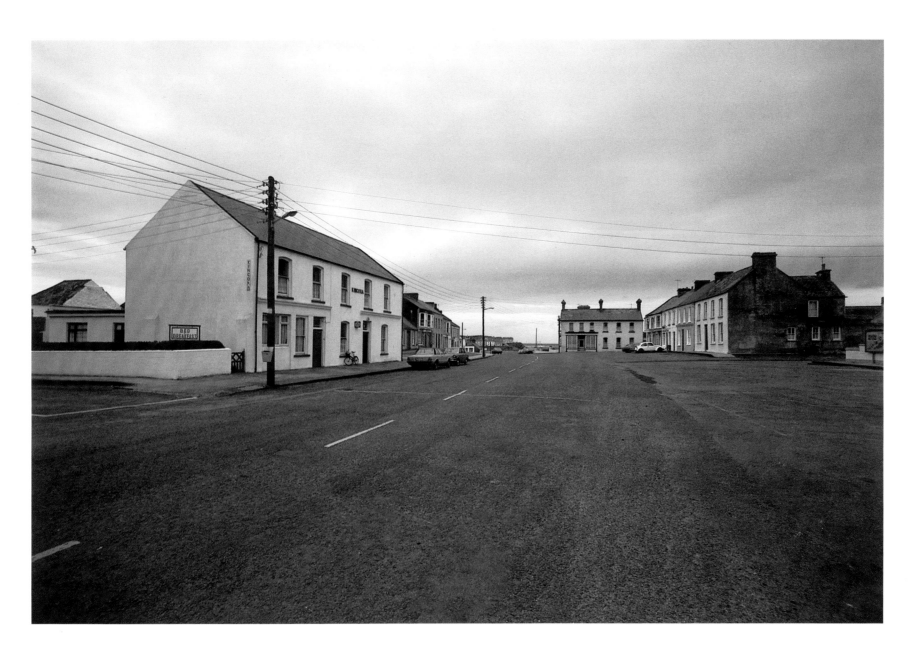

Ireland, 1979

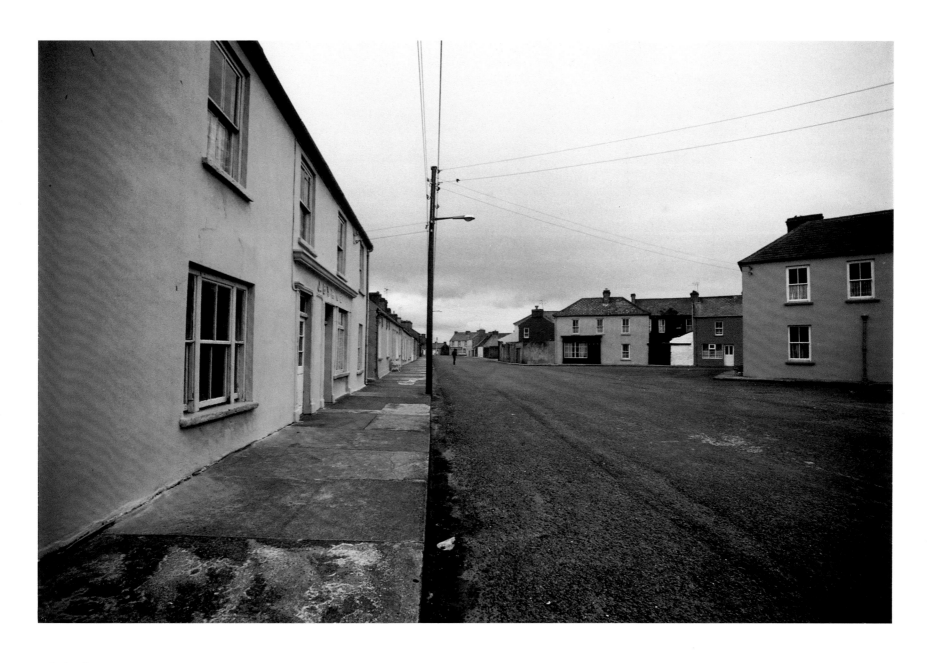

Ireland, 1979

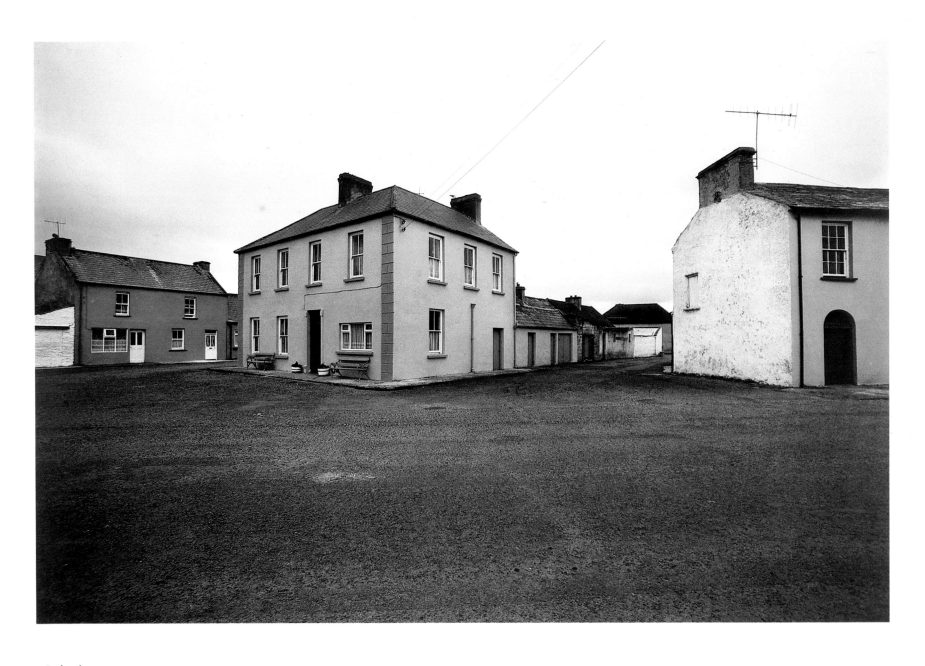

Ireland, 1979

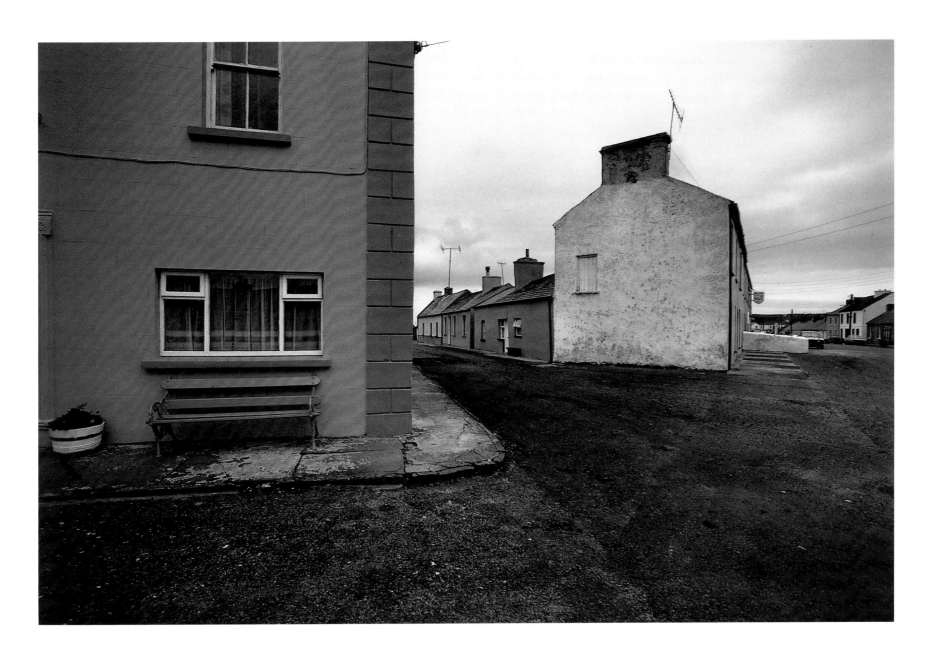

Ireland, 1979

Morocco, 1981

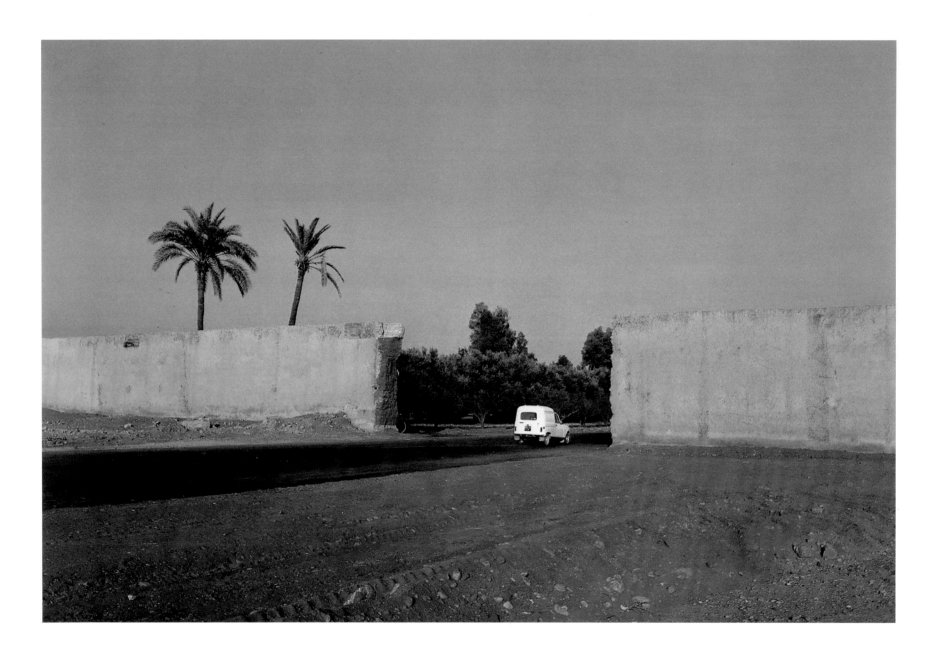

Morocco, 1981

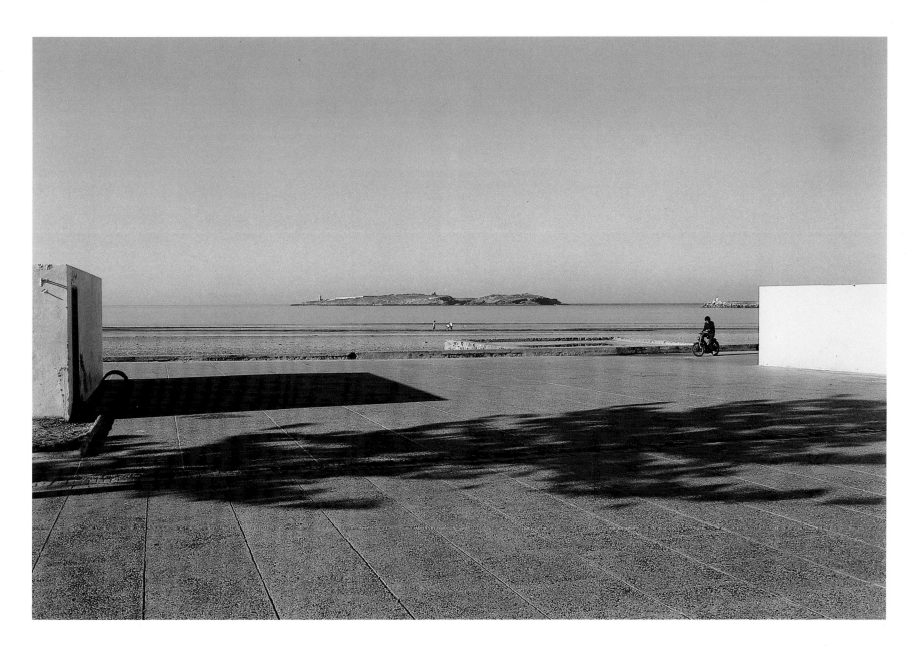

Morocco, 1981

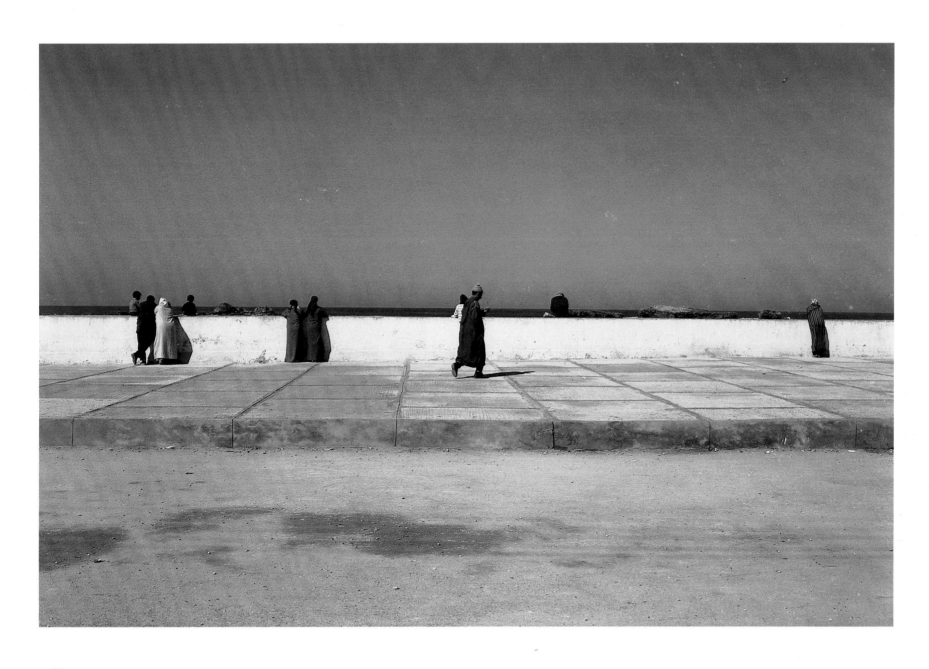

Morocco, 1981

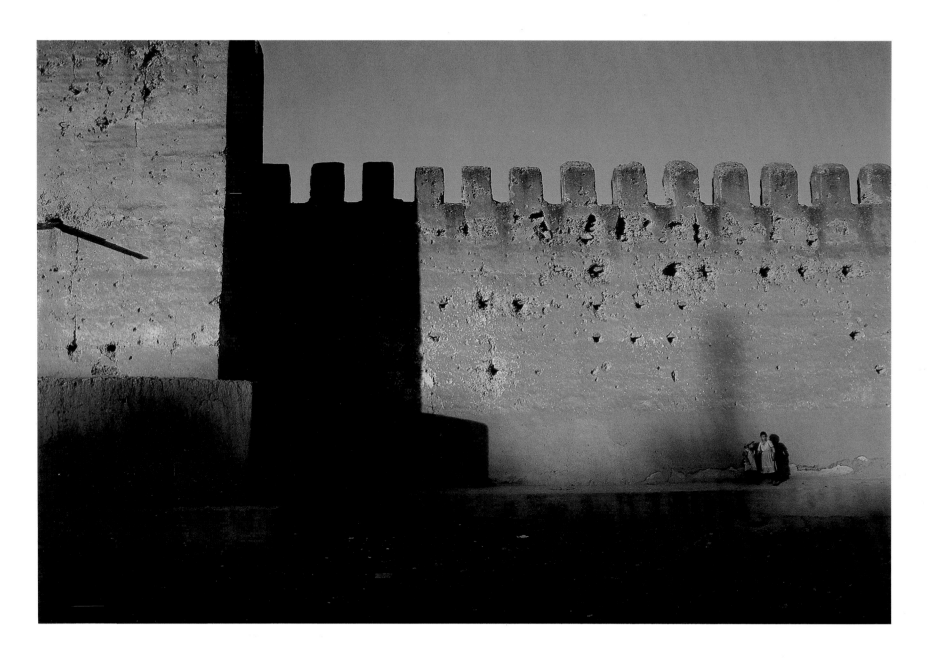

Morocco, 1981

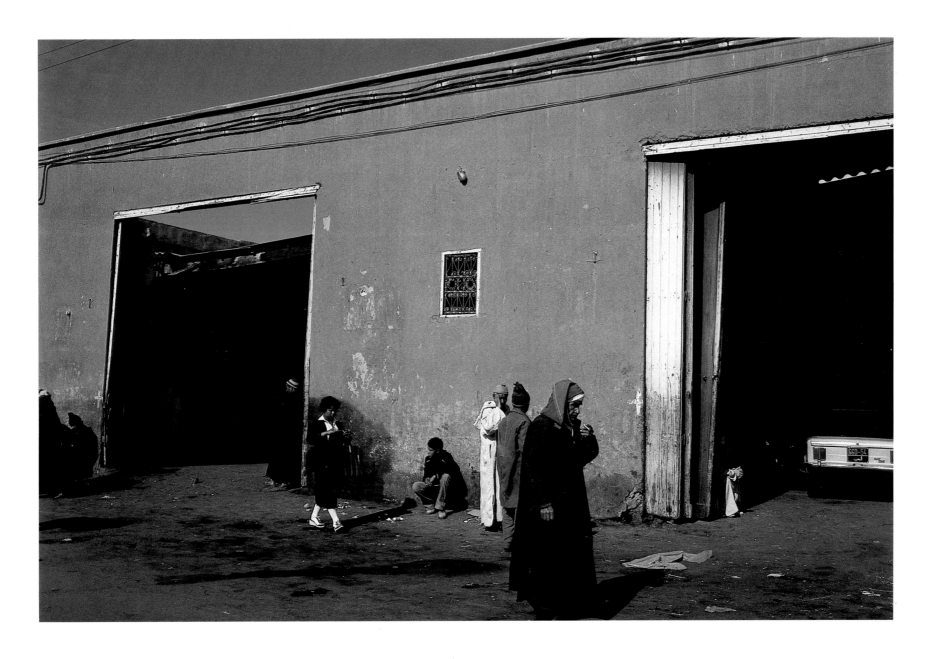

Morocco, 1981

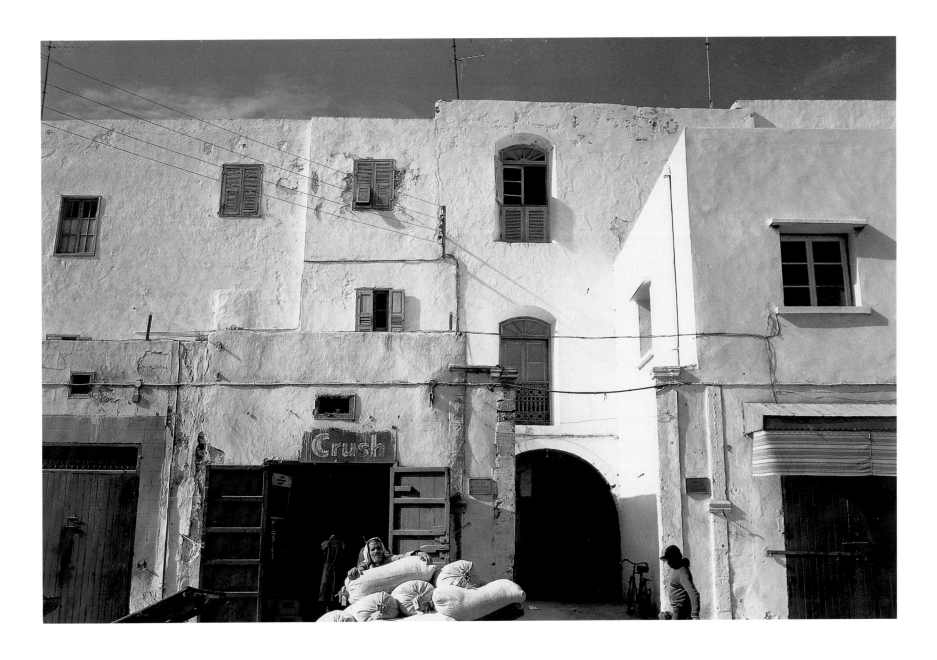

Morocco, 1981

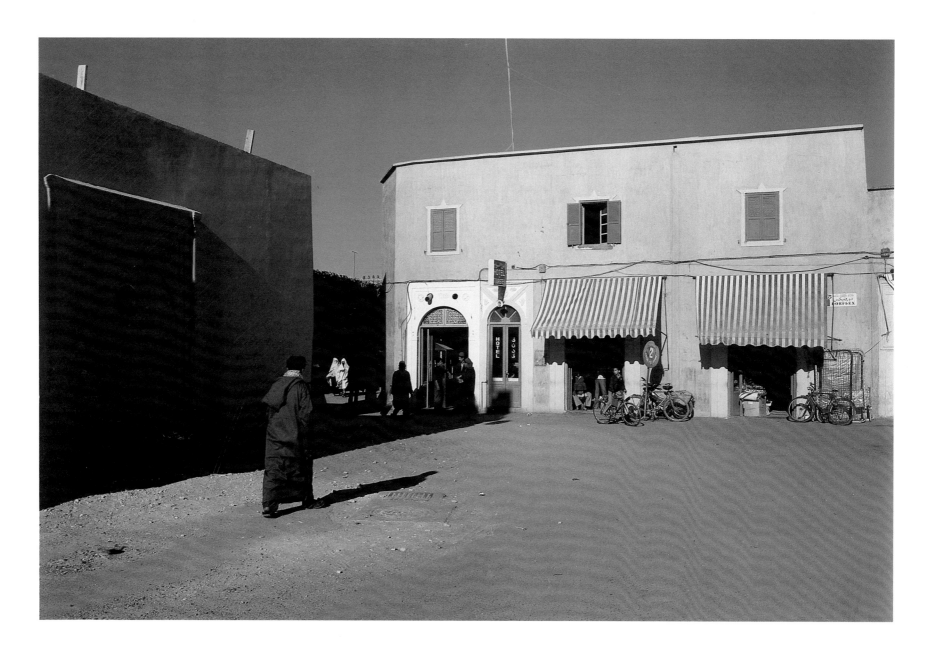

Morocco, 1981

52

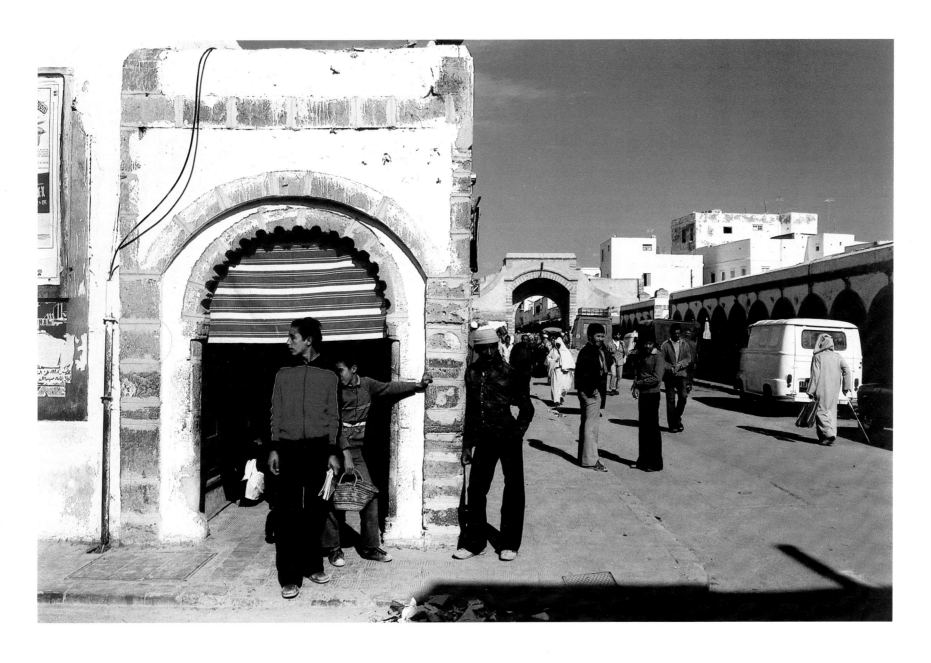

Morocco, 1981

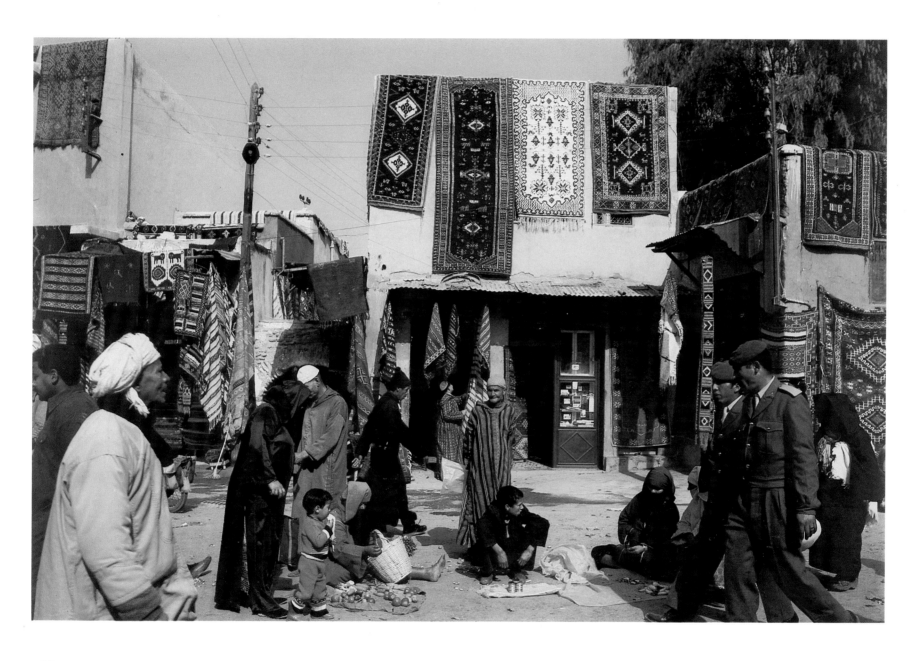

Morocco, 1981

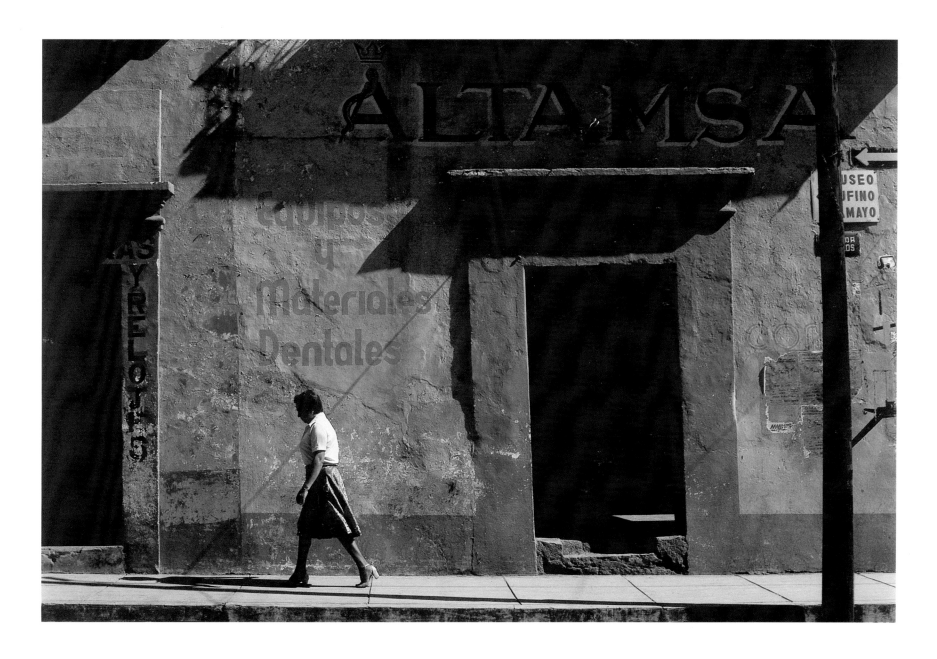

Mexico, 1982

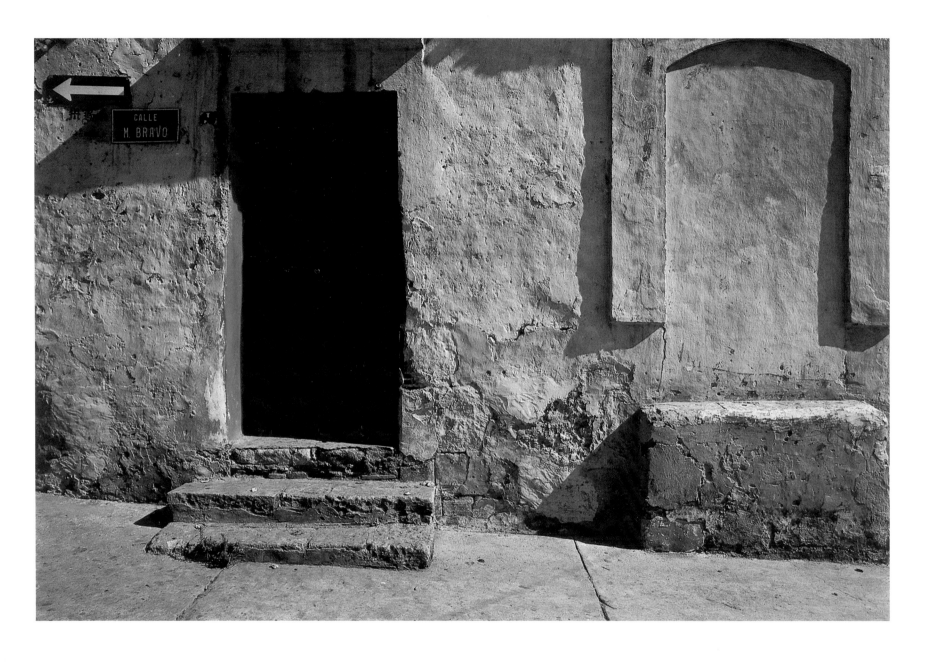

Mexico, 1982

Mexico, 1982

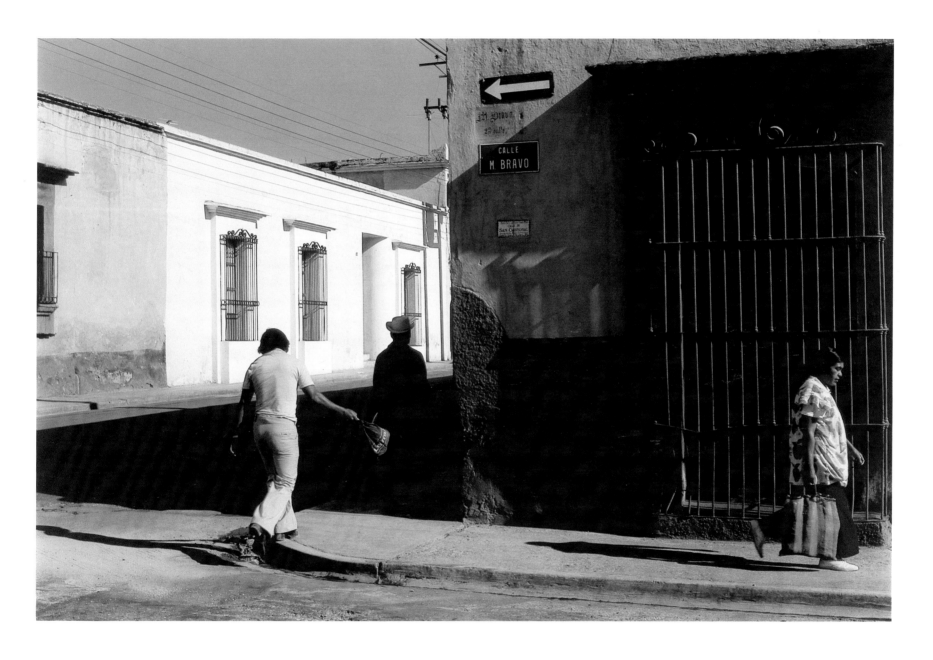

Mexico, 1982

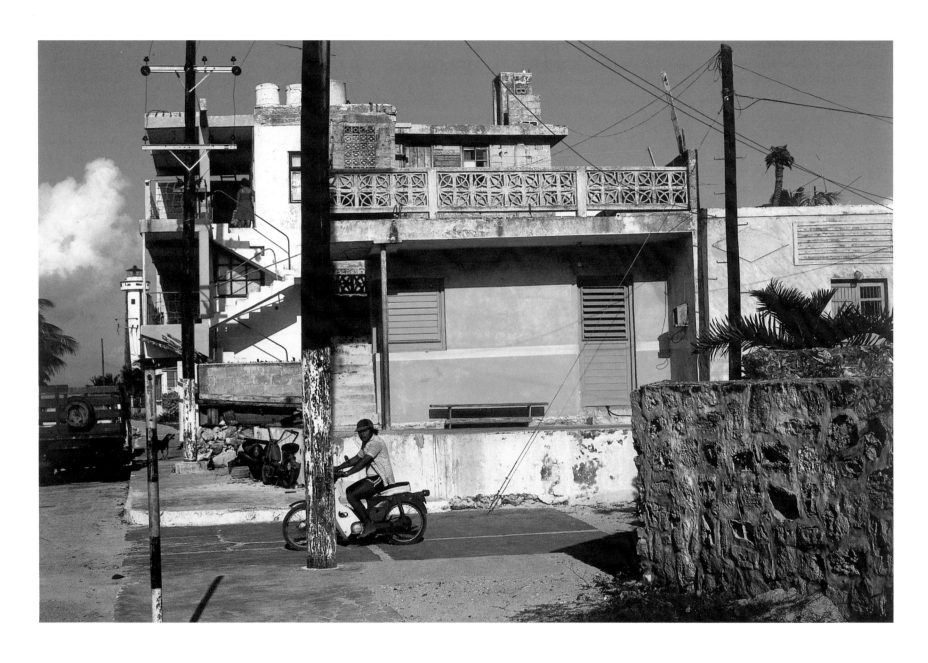

Mexico, 1983

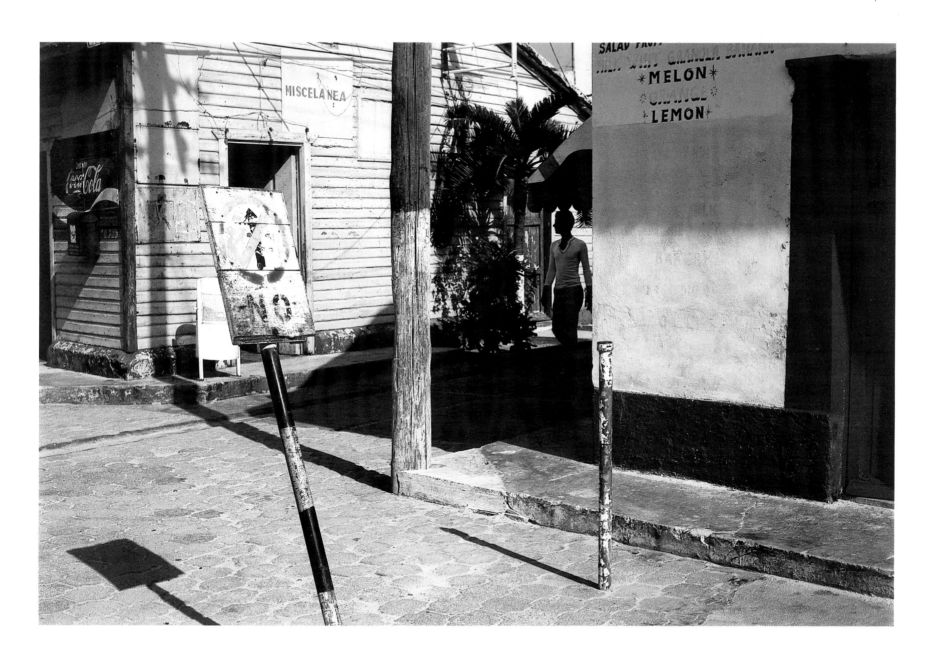

Mexico, 1983

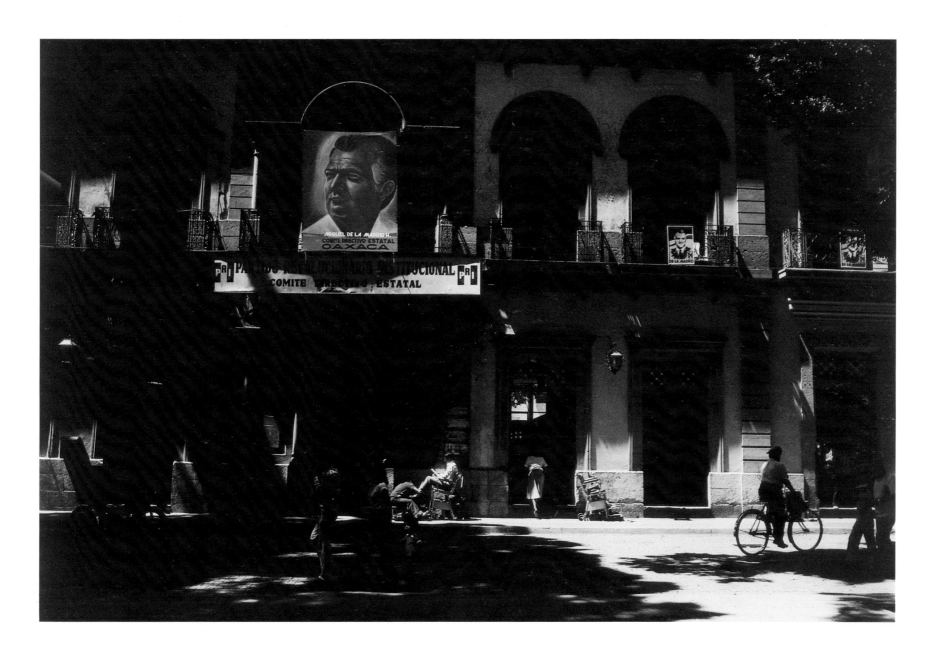

Mexico, 1982

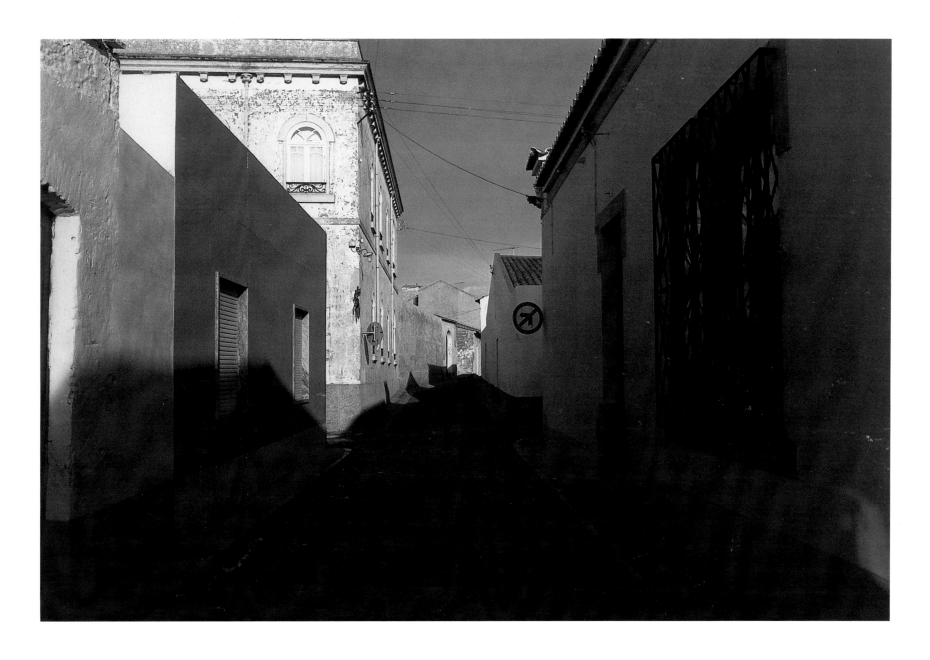

Portugal, 1982

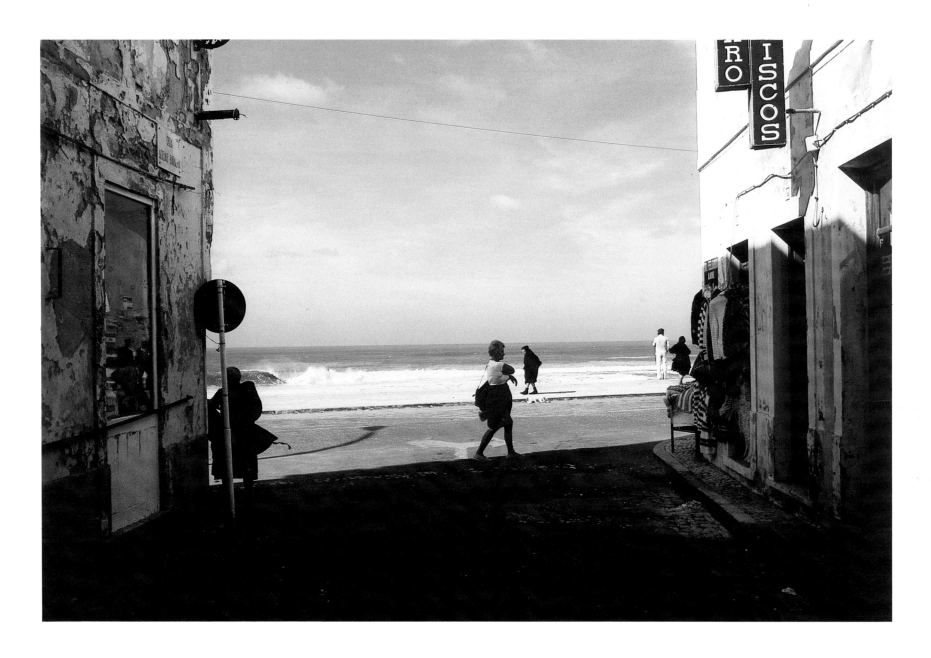

Portugal, 1982

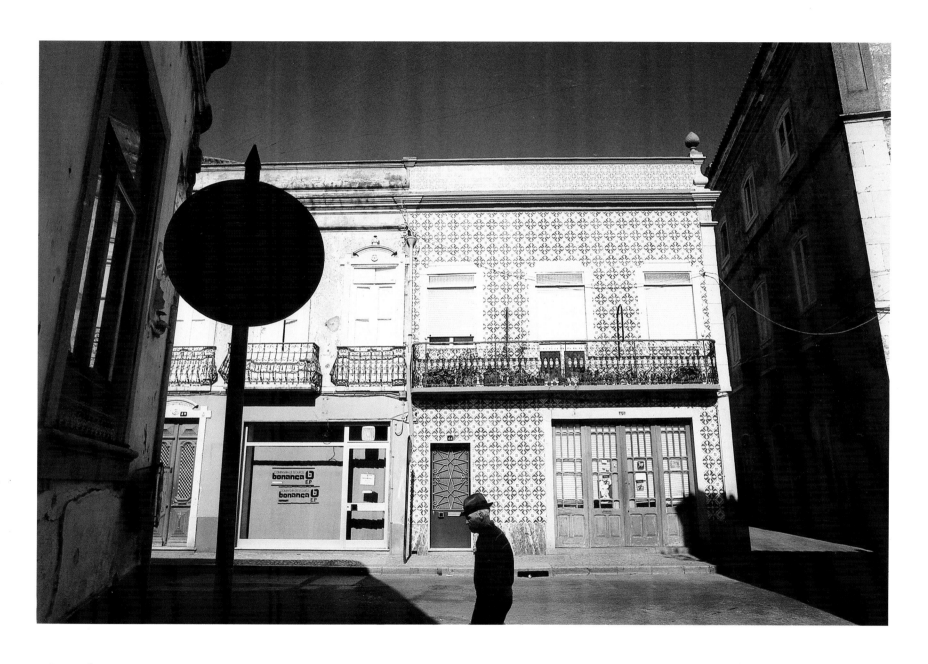

Portugal, 1982

Portugal, 1982

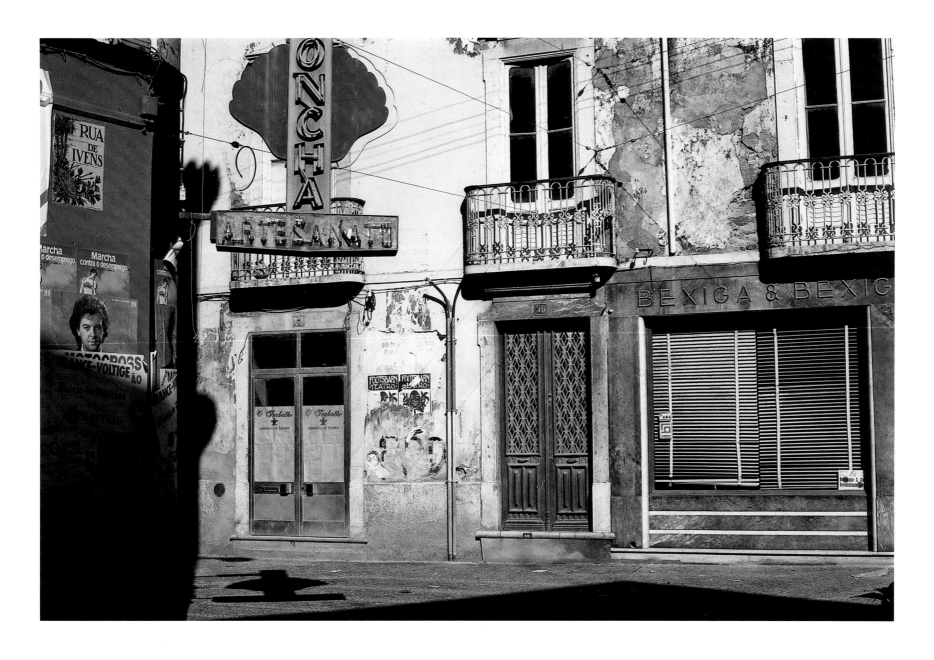

Portugal, 1982

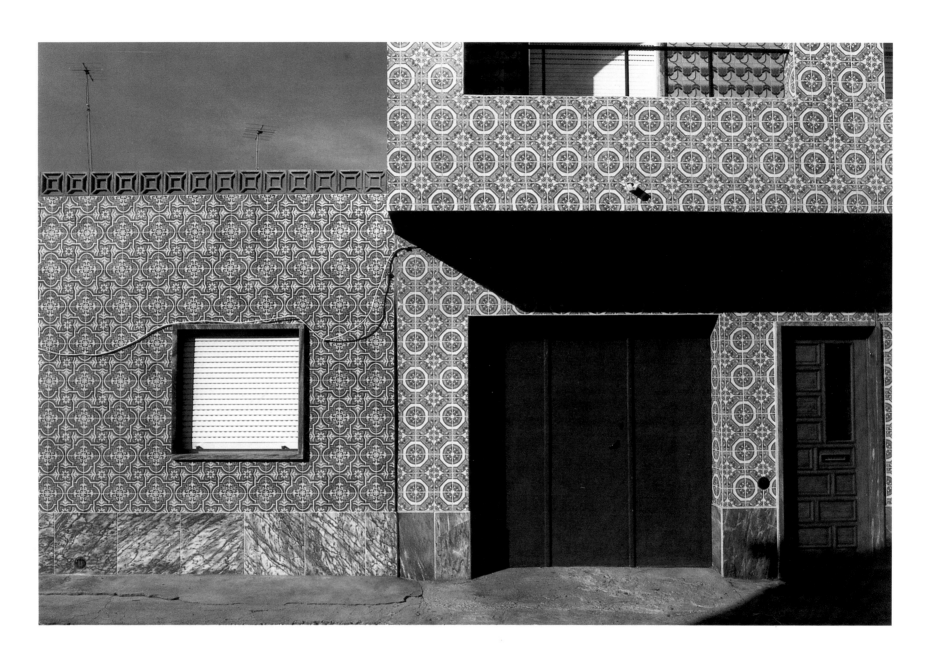

Portugal, 1982

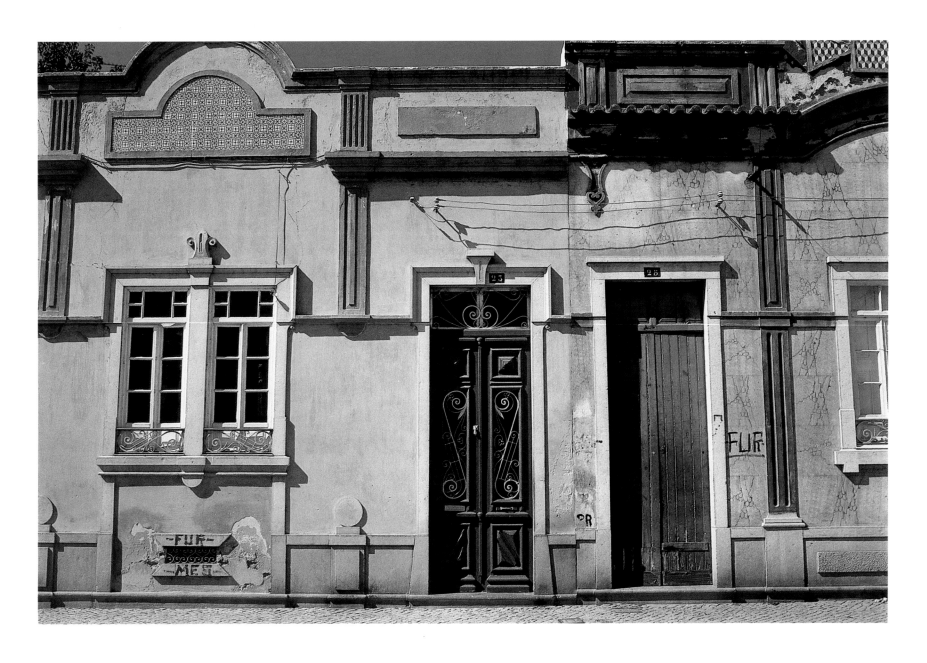

Portugal, 1982

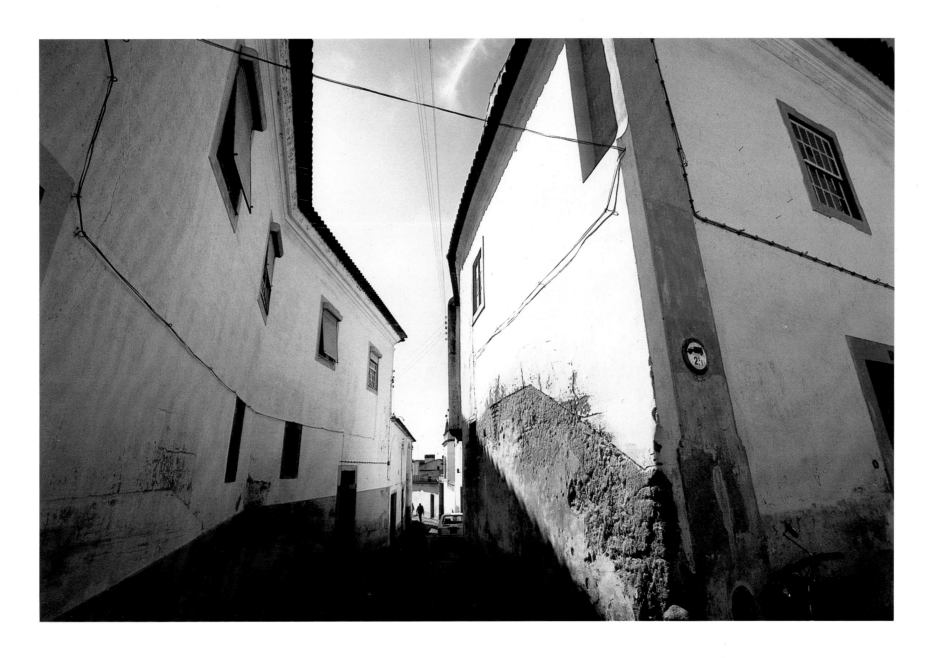

Portugal, 1982

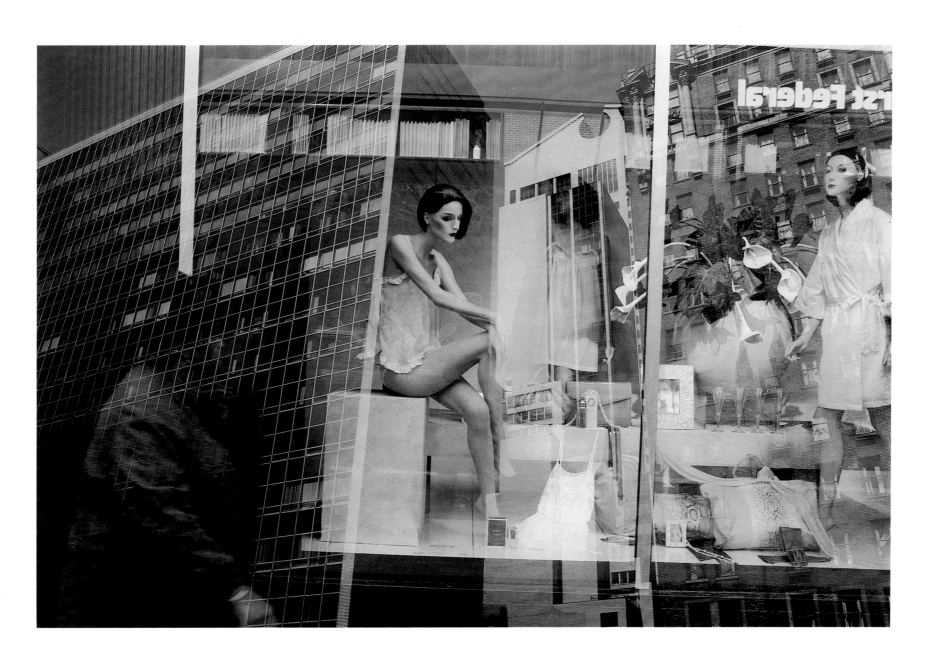

New York, 1984

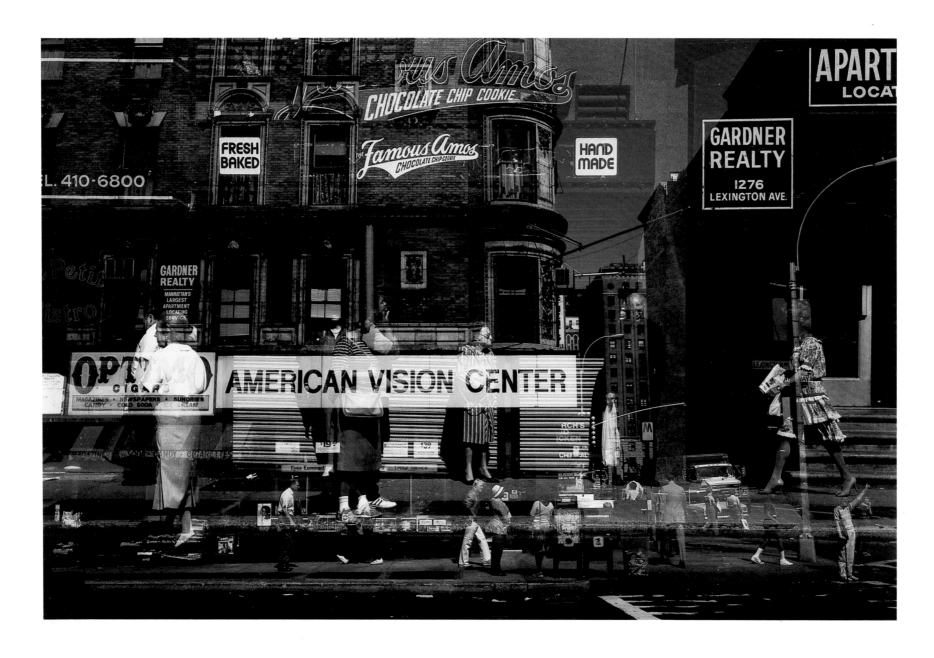

New York, 1985

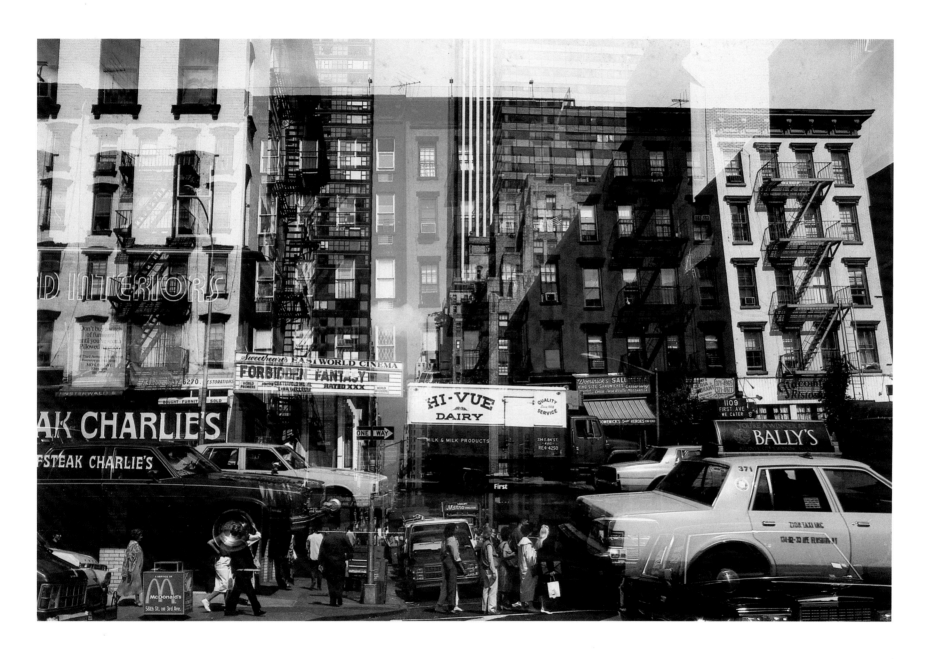

New York, 1985

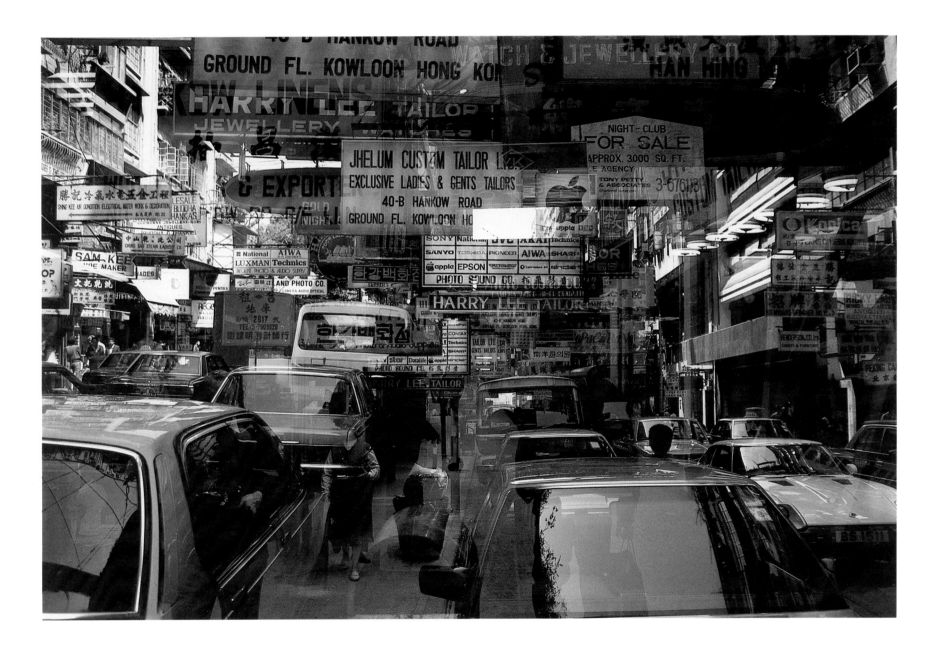

Hong Kong, 1985

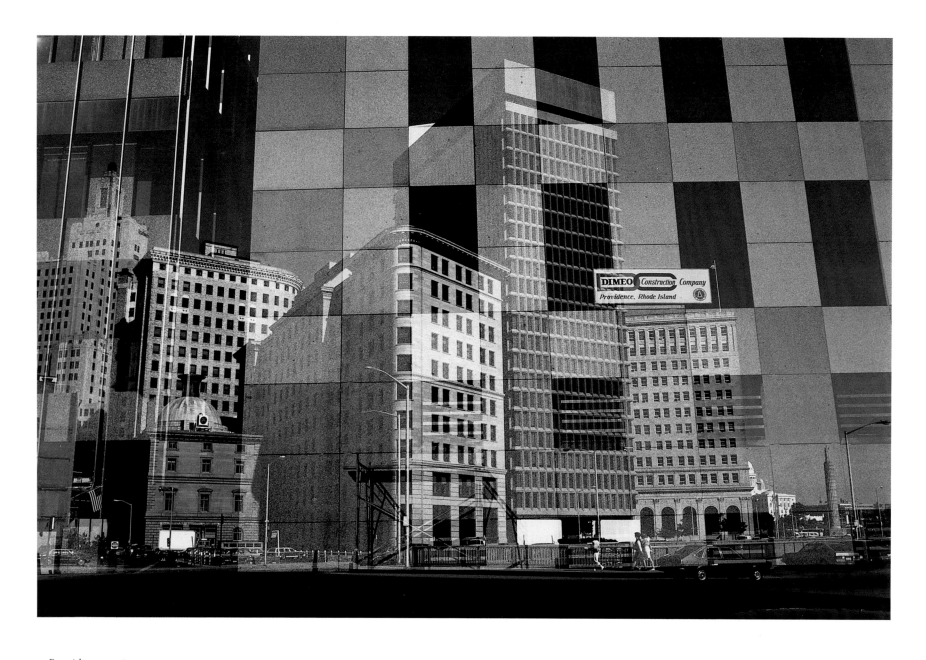

Providence, 1984

90

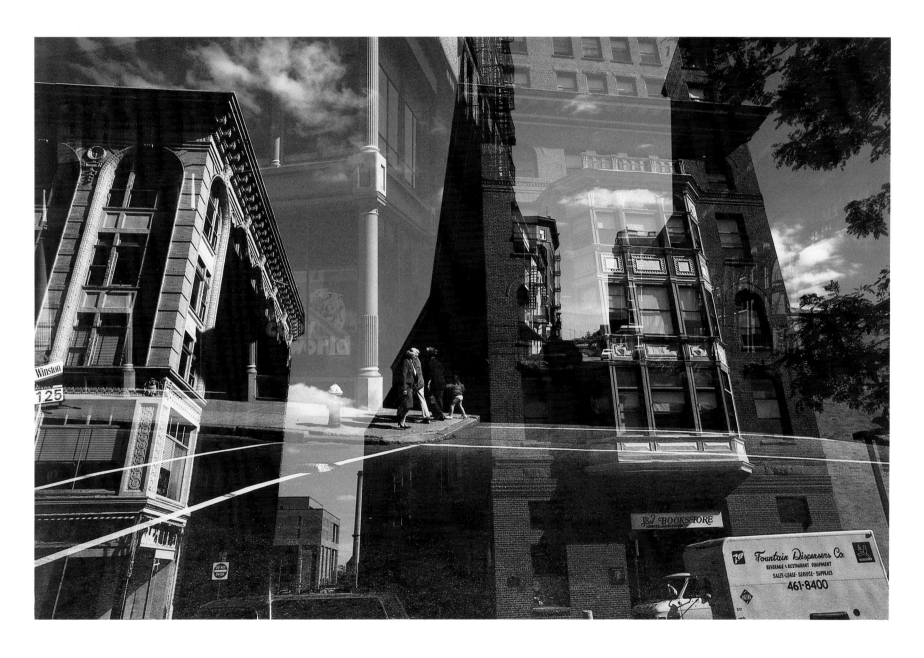

Providence, 1986

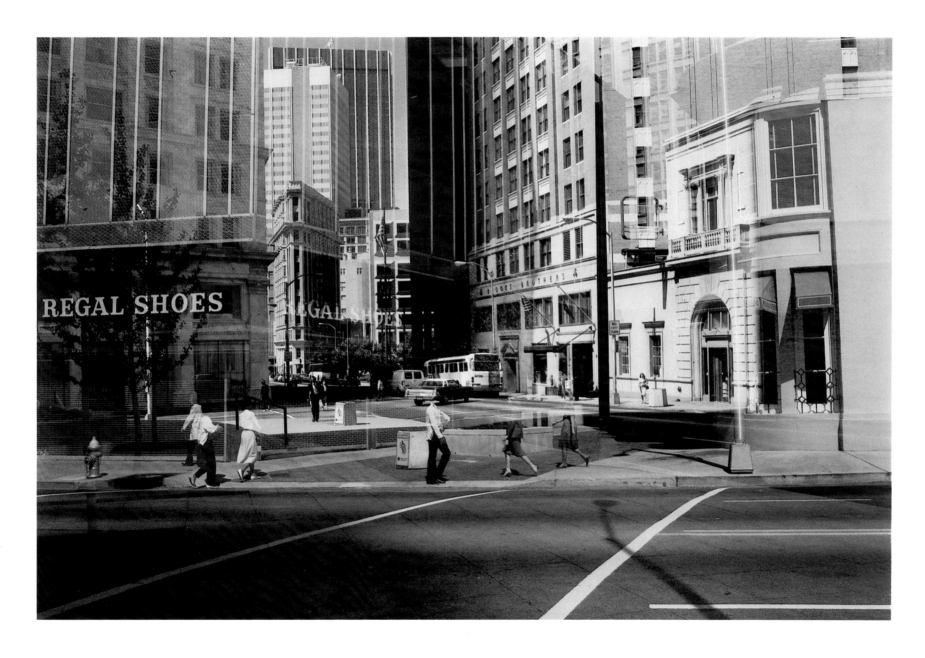

Atlanta, 1984

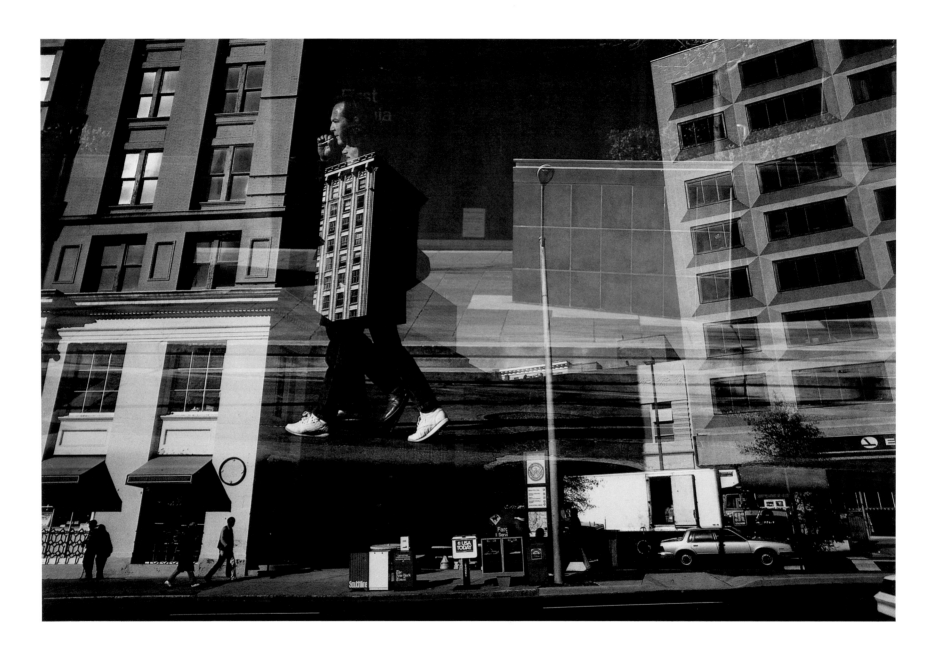

Atlanta, 1985

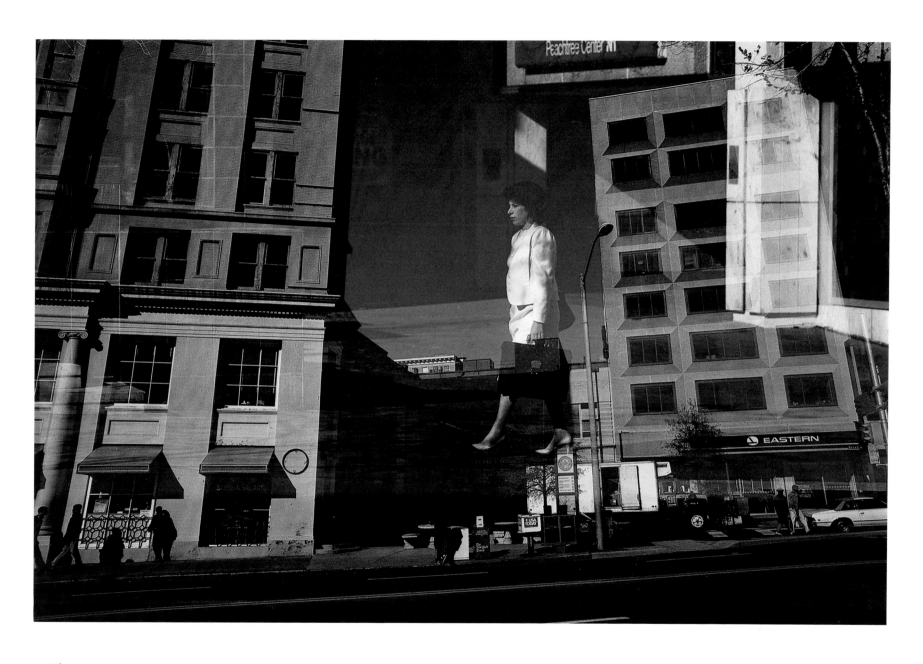

Atlanta, 1985

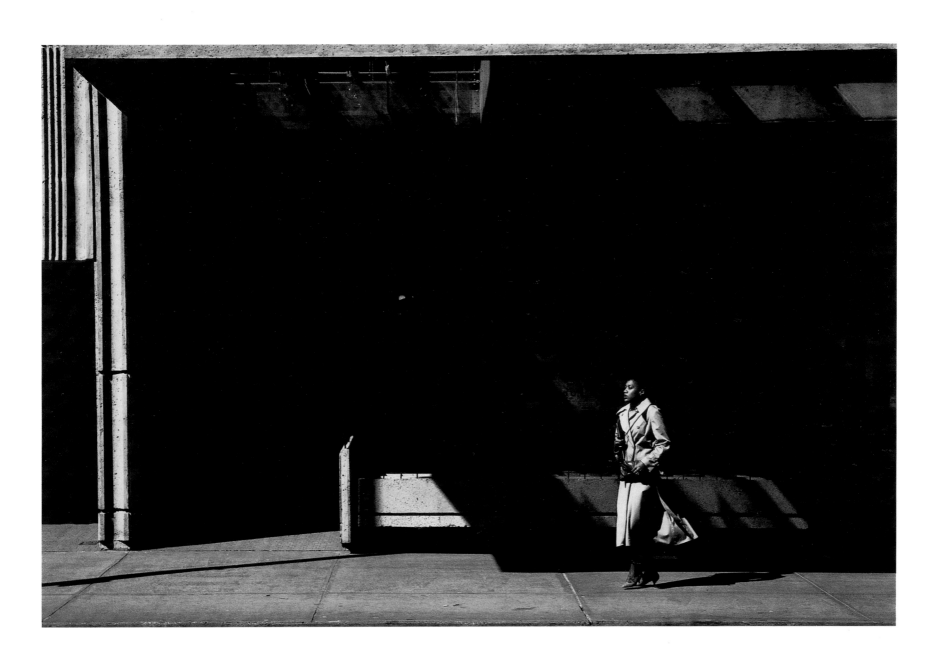

Atlanta, 1984

Atlanta, 1985

Atlanta, 1984

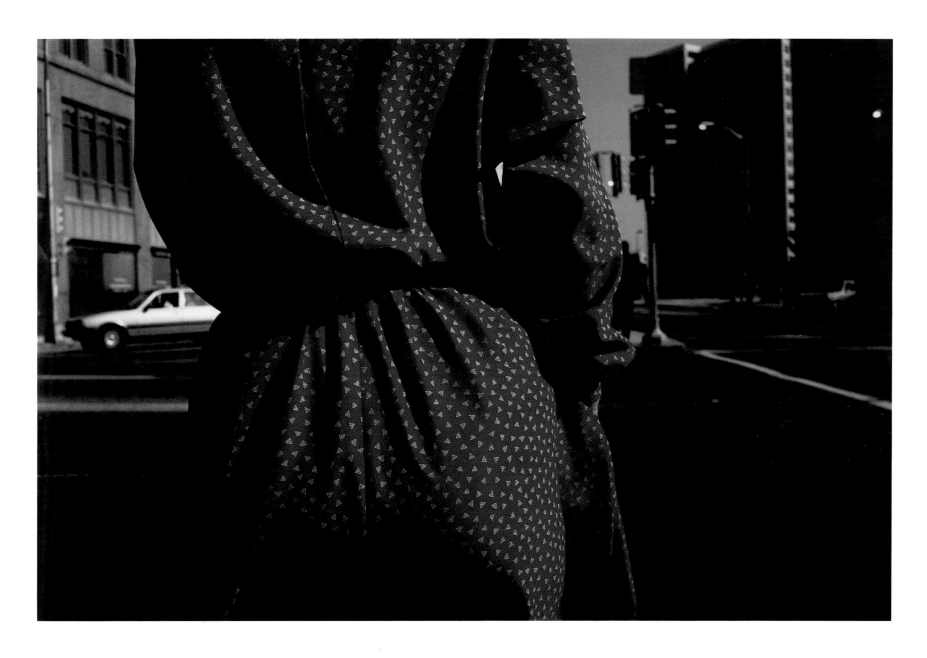

Atlanta, 1984

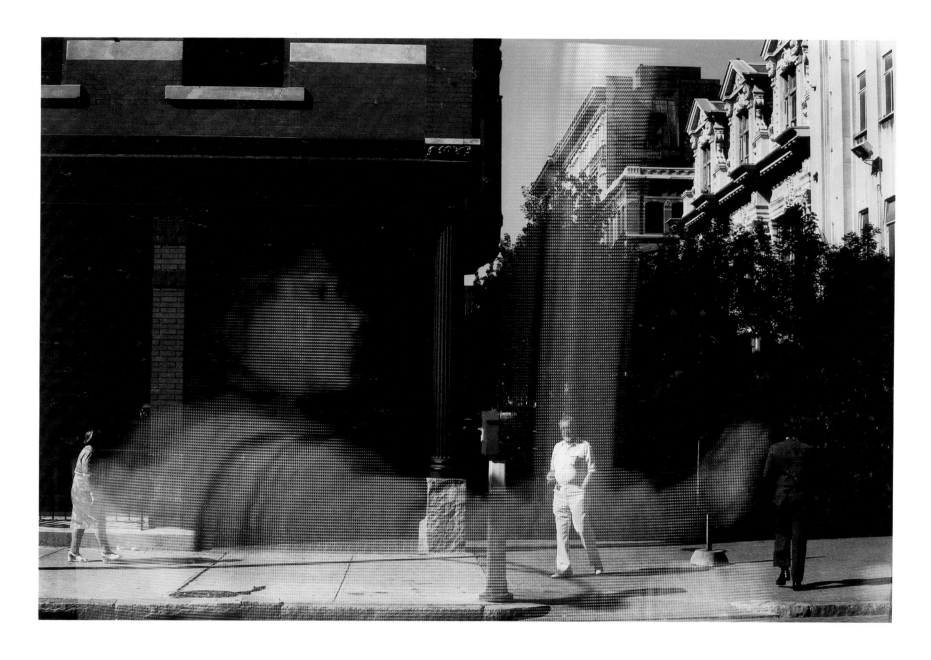

Providence, 1984

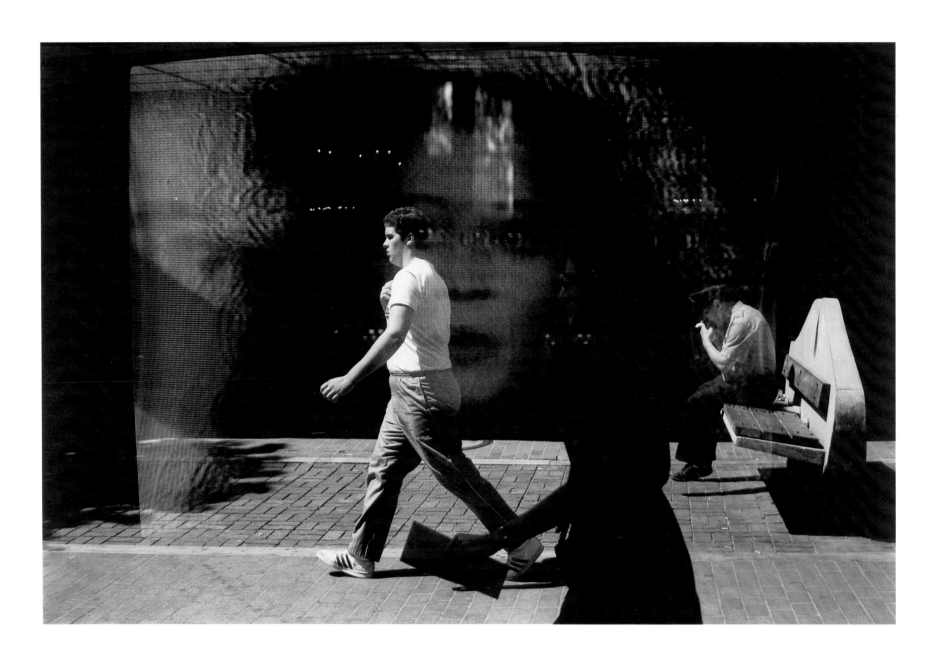

Providence, 1984

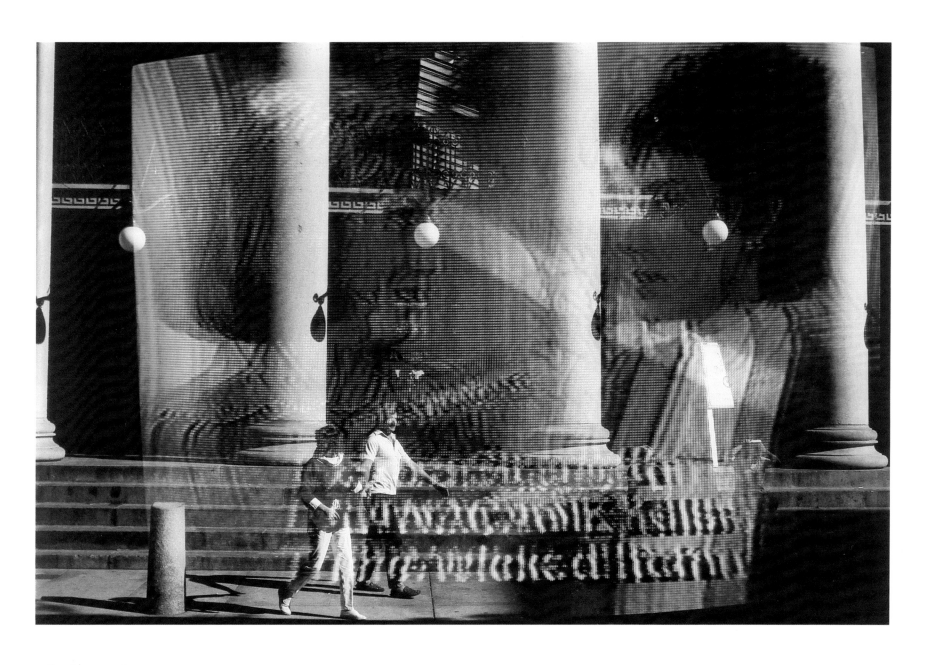

Providence, 1984

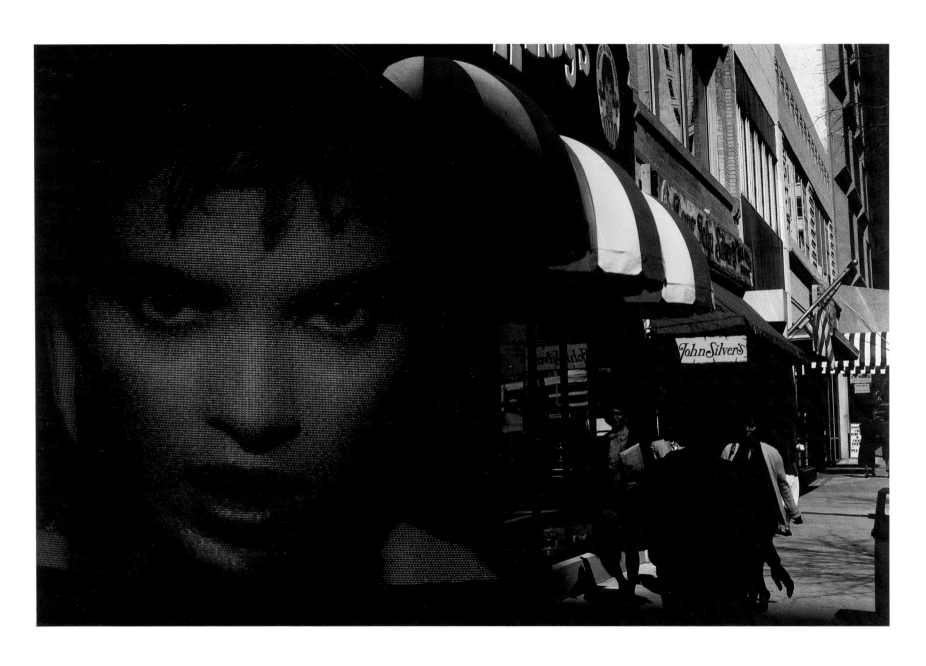

Atlanta, 1985

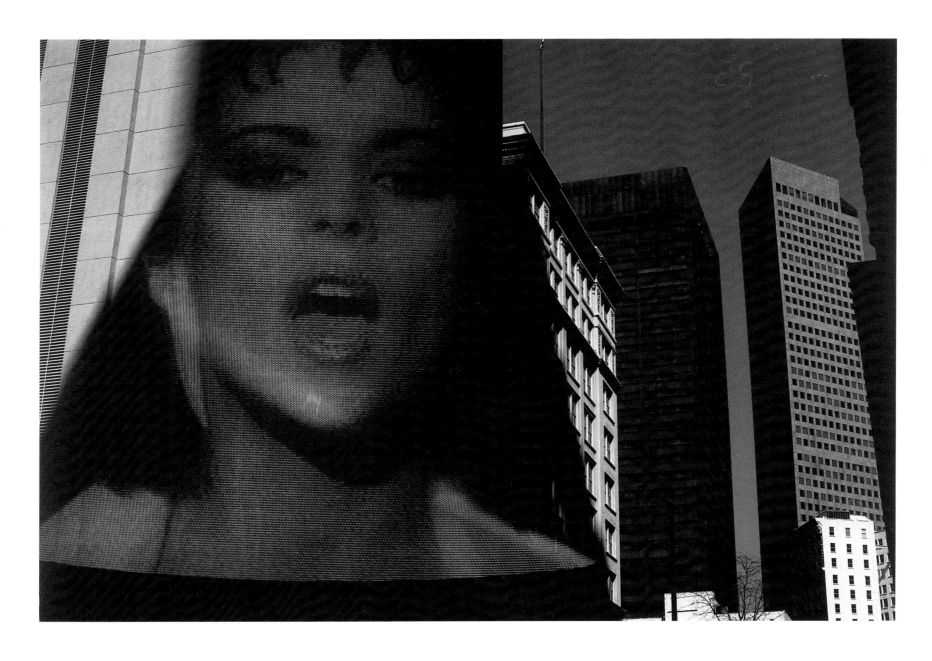

Atlanta, 1985

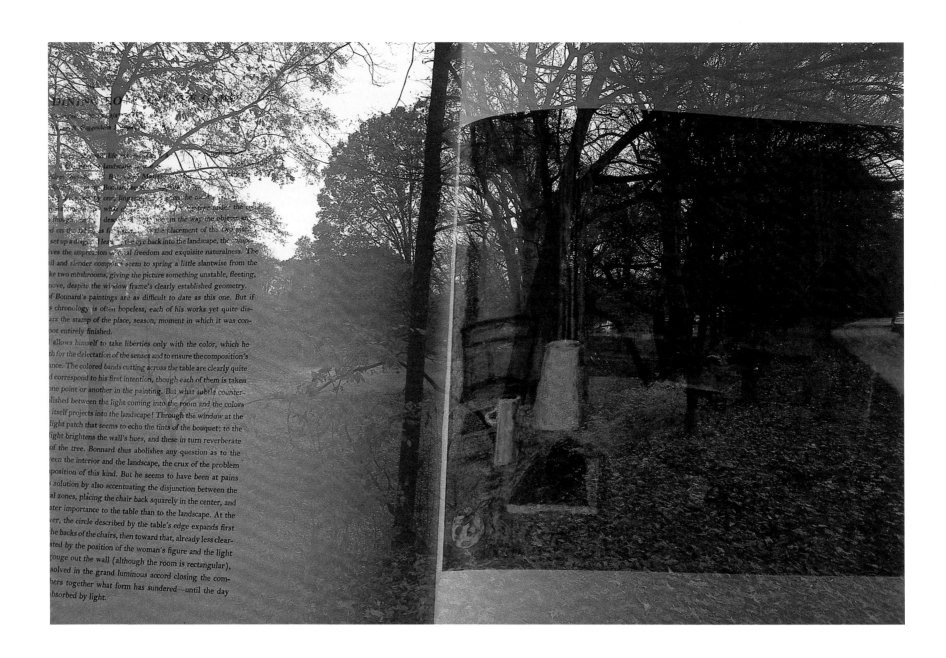

The text visible through the image reads (partially obscured):

DINING ROOM ON THE GARDEN

Suggested by

life...
...landscape...
Bonnard...
...one, ling...
...which... ...the un...
...though... ...des... ...ing... in the way the objects ar...
...on the table... as f... ...the placement of the two pitc...
...set up a diag... ...lead... ...the eye back into the landscape, the compo...
...ives the impression of ...al freedom and exquisite naturalness. The
...il and slender compot... seem to spring a little slantwise from the
...ke two mushrooms, giving the picture something unstable, fleeting,
...nove, despite the window frame's clearly established geometry.
...f Bonnard's paintings are as difficult to date as this one. But if
...s chronology is often hopeless, each of his works yet quite dis-
...rs the stamp of the place, season, moment in which it was con-
...not entirely finished.

...allows himself to take liberties only with the color, which he
...th for the delectation of the senses and to ensure the composition's
...ance. The colored bands cutting across the table are clearly quite
...d correspond to his first intention, though each of them is taken
...one point or another in the painting. But what subtle counter-
...lished between the light coming into the room and the colors
...itself projects into the landscape! Through the window at the
...light patch that seems to echo the tints of the bouquet; to the
...light brightens the wall's hues, and these in turn reverberate
...of the tree. Bonnard thus abolishes any question as to the
...een the interior and the landscape, the crux of the problem
...position of this kind. But he seems to have been at pains
...solution by also accentuating the disjunction between the
...al zones, placing the chair back squarely in the center, and
...ater importance to the table than to the landscape. At the
...ver, the circle described by the table's edge expands first
...he backs of the chairs, then toward that, already less clear-
...sted by the position of the woman's figure and the light
...gouge out the wall (although the room is rectangular),
...solved in the grand luminous accord closing the com-
...hers together what form has sundered—until the day
...bsorbed by light.

Still Life, 1984

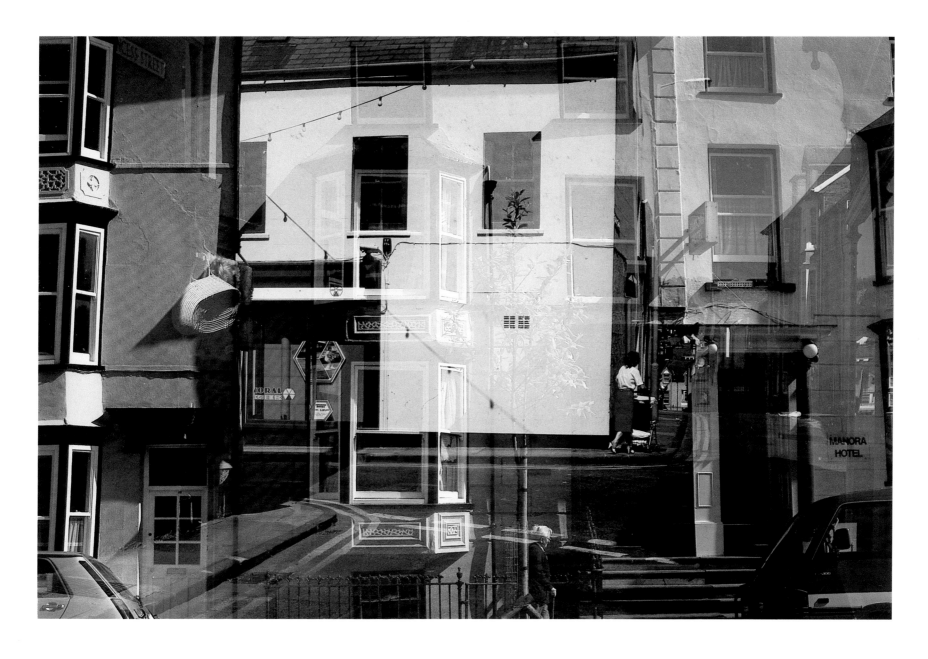

Wales, 1985

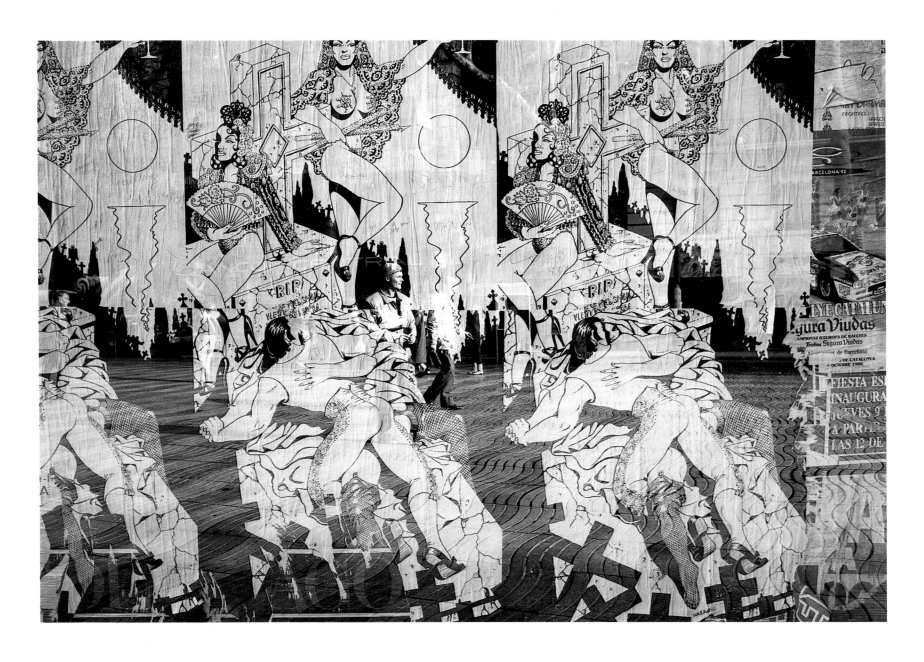

Barcelona, 1986

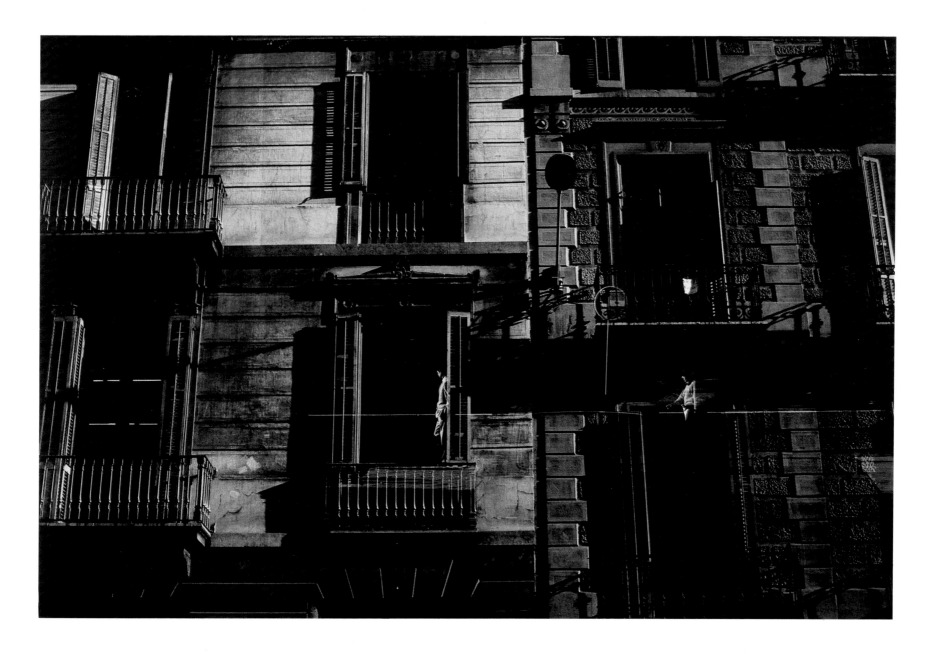

Barcelona, 1986

117

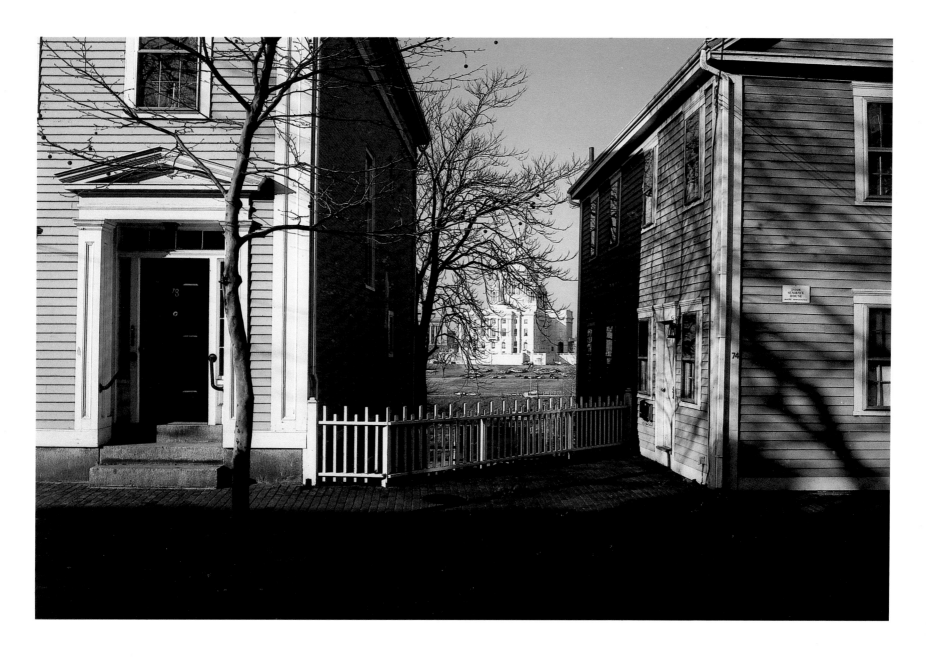

Providence, 1981

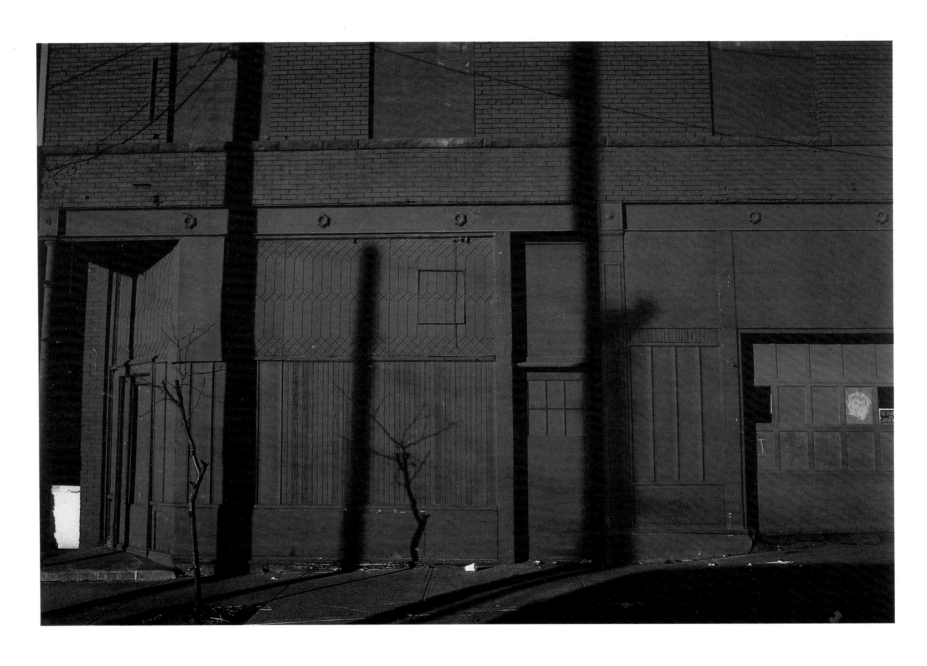

Kansas City, 1981

Asheville, 1986

121

Cape Cod, 1987

Selected Bibliography: 1978-87

Each section of the bibliography is arranged chronologically

MONOGRAPHS

Peter C. Bunnell. *Harry Callahan: 38th Venice Biennial 1978*. New York: American Federation of Arts, 1978. Exhibition catalog with essay, chronology, bibliography, and summaries of group and one-person exhibitions. Text in Italian and English. 80 pages.

Sally Stein. *Harry Callahan: Photographs in Color, The Years 1946-1978*. Tucson: Center for Creative Photography, 1980. Exhibition catalog with introduction by Terence R. Pitts, text by Stein, and chronology, bibliography, and exhibition checklist. Published to accompany a traveling show organized by the Center for Creative Photography. 40 pages.

Robert Tow and Ricker Winsor, editors. *Harry Callahan: 1941-1980*. Providence: Matrix Publications, 1980. Slipcased volume with foreword by Jonathan Williams, essay by A. D. Coleman, chronology by Dolores A. Knapp, and bibliography by Anne Kirby. Unpaginated (144 pages).

Harry Callahan. *Water's Edge*. Lyme, Connecticut: Callaway Editions, 1980. Volume includes an introductory poem by A. R. Ammons and an afterword by Callahan. Unpaginated (74 pages).

Keith F. Davis. *Harry Callahan: Photographs*. Kansas City: Hallmark Cards, Inc., 1981. Exhibition catalog with introduction and essay by Davis, and reminiscence by Callahan (edited by Davis from eight-hour videotape interview conducted in 1977 by the Center for Creative Photography, Tucson). Published to accompany traveling retrospective from the Hallmark Photographic Collection. 64 pages.

The Photographs of Harry Callahan: 1941-1982. Tokyo: Seibu Museum of Art, 1983. Exhibition catalog with interview by Shelley Rice, biographic outline, bibliography, and reproductions of all 110 photographs in exhibition. Text in Japanese and English. 108 pages.

Louise E. Shaw, Virginia Beahan, and John McWilliams. *Harry Callahan and His Students: A Study in Influence*. Atlanta: Georgia State University Art Gallery, 1983. Exhibition catalog with essay by Shaw, interviews or statements by thirteen former students, checklist of prints in exhibition, and bibliography. Unpaginated (70 pages).

Anne Kennedy and Nicholas Callaway, editors. *Eleanor: Photographs by Harry Callahan*. Carmel: Friends of Photography, 1984. Volume includes essay and chronology by James Alinder, list of plates and exhibition schedule for the show assembled by the Center for Creative Photography. 64 pages.

Susan Beardmore, editor. *Harry Callahan: Retrospective 1941-1982*. Cardiff, Wales: The Ffotogallery, 1985. Exhibition catalog with essay by Susan Butler, chronology, and schedule for U.K. exhibition tour. Unpaginated (32 pages).

SELECTED ARTICLES, INTERVIEWS, REVIEWS, AND PUBLISHED PORTFOLIOS

1978 William Wilson. "Excellence in the Middle of the Road." *Los Angeles Times Calendar*, April 2, 1978, p. 98.

Leo Rubinfien. "Harry Callahan's Detente with Experience." Village Voice, April 10, 1978, p. 81.

Stuart Liebman. "Callahan's Puritan Color." *The Soho Weekly News*, April 13, 1978, p. 22.

Lorraine Hopkins. "Harry Callahan Converses with his Eye and is Answered by Venice." *The Providence Sunday Journal* (Providence, Rhode Island), June 18, 1978, p. E-1.

David Elliott. "Mies With a Camera." *The Chicago Sun Times*, October 15, 1978.

1979 R. Luyster. "Platonism, Despair and Harry Callahan." *British Journal of Photography (London)*, May 18, 1979, pp. 463-66.

W. Messer, "Viewed: Harry Callahan's Landscapes at the Camden Arts Centre." *British Journal of Photography* (London), July 13, 1979, pp. 670-71.

Yvette E. Benedek. "Contact." *American Photographer*, August 1979, p. 69.

Melissa Shook. "Harry Callahan: Interviewed by Melissa Shook." *Picture Magazine* (Los Angeles), Issue 12, 1979.

Renato Danese, editor. *American Images: New Work by Twenty Contemporary Photographers*. New York: McGraw-Hill Book Company, 1979, pp. 30-39.

Jain Kelly, editor. *Nude: Theory*. New York: Lustrum Press, 1979, pp. 27-47. Included are statements by the artist and his wife, Eleanor.

Lee Witkin and Barbara London. *The Photograph Collector's Guide*. Boston: New York Graphic Society, 1979, pp. 101-2.

Dennis Curtin and Joe DeMaio, *The Darkroom Handbook*. New York: Van Nostrand Reinhold Co., 1979, pp. 4-5.

1980 Marcianne Herr. "Harry Callahan: Color Photographs." *Dialogue*, May-June 1980, pp. 8-9. Review of exhibition at Akron Art Institute, Akron, Ohio.

Colin Westerbeck, Jr. "The New Vision." *Artforum*, September 1980, pp. 67-68.

Gene Thornton. "Harry Callahan's Discerning Use of Color." *New York Times*, September 7, 1980, Section II, p. 33.

Pepe Karmel. "Photography Under Moholy's Eye: A Retrospective from Chicago's Institute of Design." *Art in America*, October 1980, p. 39.

Nancy Stevens. "Harry Callahan: A man revered for his black and white observations has been quietly working in color for years." *American Photographer*, October 1980, pp. 68-75.

Mark Johnstone. "Harry Callahan and Stephen Shore open new gallery: Light Gallery, Los Angeles." *Artweek*, November 1, 1980, p. 13.

Alan G. Artner. "Photo Artistry fills pages of *Harry Callahan: Color*." *Chicago Tribune*, November 2, 1980, Arts and Books section, pp. 8-9.

Hilton Kramer. "Photography." *New York Times Book Review*, November 30, 1980, p. 13.

Laura Pevsner. "The Images of Harry Callahan." *Art New England*, December 1980, p. 18.

"Harry Callahan: Light Gallery, New York." *Artnews*, December 1980, p. 192.

John Pantalone. "Callahan the Photographer." *East Side/West Side* (Providence, Rhode Island), December 11, 1980, pp. 6A-7A, 16A.

Charles Michener. "A Season of Photography Books." *The New Republic*, December 13, 1980, p. 31.

Helen Gee. *Photography of the Fifties: An American Perspective*. Tucson: Center for Creative Photography, 1980, pp. 60-65.

Landscape: Theory. New York: Lustrum Press, 1980, pp. 41-57. Includes lengthy statement by the artist.

Janet Malcolm. *Diana & Nikon: Essays on the Aesthetics of Photography*. Boston: David R. Godine, 1980, pp. 122-28.

Rod Slemmons, editor. *American Photographs: 1970 to 1980: The Washington Arts Consortium*. Seattle: Washington Arts Consortium, 1980, pp. 22, 54.

Charles Traub, editor. *The New Vision: Forty Years of Photography at the Institute of Design*. Millerton, New York: Aperture (Issue 87), 1980.

1981 Lisa Gerber. "Photos by Callahan." *Lawrence Journal-World* (Lawrence, Kansas), January 11, 1981, p. 7B.

Donald Hoffman. "A Passion for Pictures," and "Master Photographer Makes the Meek Mighty as He Focuses on the Usual." *Kansas City Star* (Kansas City, Missouri), January 25, 1981, pp. 1D, 3D.

William Kay. "Harry Callahan: An Interview." *Forum* (Kansas City, Missouri), February 1981, pp. 10-11.

Peter C. Bunnell. "La Beauté Neuve de la Photographie." *Connaissance des Arts*, February 1981, pp. 58-63.

Michael Pretzer. "Views News: PRC Notes." *Views* (Boston), Winter 1981, p. 3.

Jan Zita Grover. "Callahan Collected." *Afterimage*, March 1981, pp. 4-5.

"Friends Honor Callahan, Friedlander." *Afterimage*, March 1981, p. 3.

Vicki Goldberg. "Review of Books: Photography." *Art in America*, March 1981, p. 21.

"Bücher: Harry Callahan: Color." *Printletter*, March-April 1981, pp. 29, 30. Review in German and English.

"Bücher: Ausgewählte Photographien von Harry Callahan: A fine selection of Callahan photographs." *Printletter*, May-June 1981, pp. 33-34.

Melissa Shook. "Books: Disturbances: Callahan in black-and-white and color." *Camera Arts*, May-June 1981, pp. 26, 28, 111-13.

Gerry Badger. "*Water's Edge* and *Harry Callahan: Color*." *Creative Camera*, August 1981, p. 194.

Jim Buie. "Photography: 'Art for the People'." *The News and Observer* (Raleigh, North Carolina), August 28, 1981, pp. 15-16.

Roger Catlin. "A Master's Photos Displayed." *Sunday World-Herald* (Omaha, Nebraska), November 15, 1981, p. 32.

Gretchen Garner. "Reviews." *Exposure* 19:2, 1981, pp. 58-59.

James Alinder. "Harry Callahan: Distinguished Career in Photography." *Untitled* 25 (Carmel: Friends of Photography), 1981, pp. 10-15.

Barbaralee Diamondstein. *Visions and Images: American Photographers on Photography*. New York: Rizzoli, 1981, pp. 11-12. Includes interview with the artist.

1982 Dorothy Burkhart. "Fame Can't be Drawn in Black and White." *San Jose Mercury* (San Jose, California), March 11, 1982, p. 3D.

Cathy Curtis. "Stanford Displays Callahan's Simplicity." *Peninsula Times Tribune*, March 19, 1982, p. C1, C9.

"Harry Callahan: A Need to See and Express," Twenty-three-minute film produced by WGBH, Boston, for "Masters of Photography" series. Program first aired on May 10, 1982.

1983 Abigail Solomon-Godeau. "Armed Vision Disarmed: Radical Formalism from Weapon to Style." *Afterimage*, January 1983, pp. 13-14.

"Quand Callahan voit en couleurs." *Connaissance des Arts*, June 1983, p. 28.

M. C. Hugonot. "Harry Callahan." *Beaux Arts Magazine*, June 1983, pp. 60-65, 96.

Andy Grundberg. "An Artist Looks Anew in Color." *The New York Times*, June 19, 1983, pp. H35-36.

Kay Larson. "Light Fantastic." *New York*, June 27, 1983, p. 70.

Gary Michael Dault. "A Lifetime of Images Born of Innocent Passion." *Globe and Mail* (Toronto), September 3, 1983.

Christopher Hume. "A Remarkable Master of the Visual." *Toronto Star*, September 10, 1983, p. F5.

William Zimmer. "Princeton: Poetry Sans Nos-

talgia." *New York Times*, September 25, 1983.

David Livingstone. "A Look Back at a Pioneer." *MacLeans* (Toronto), October 1983.

Valerie Brooks. "Harry Callahan's True Colors." *Artnews*, October 1983, pp. 64-71.

Ed Howard, producer. "Harry Callahan: Eleanor and Barbara." Film made by the Checkerboard Foundation, which received award in the Fourth Annual Festival of Award Winning Short Subject/ Documentary Films.

1984 Alan G. Artner. "Romance Without Pain or Anxiety: Harry Callahan's Photos of Eleanor." *Chicago Tribune*, January 22, 1984, Arts Section, pp. 14-15.

P. Kjellberg. "Couleurs, formes et matières." *Connaissance des Arts*, February 1984, p. 42.

John Marlowe. "San Francisco." *West Art*, April 27, 1984.

David Levi Strauss. "The Lineaments of Gratified Desire." *Artweek*, June 2, 1984, p. 11.

Andy Grundberg. "When Woman is Idealized Without Resorting to Cliche." *New York Times*, July 1, 1984.

Martha Chahroudi. "Eleanor, Chicago." *Bulletin of the Philadelphia Museum of Art* 80, Summer/ Fall 1984, pp. 32-34.

Julia Scully, "Seeing Pictures." *Modern Photography*, August 1984, pp. 18, 36.

Joy Colby. "His Family 'Snapshots' Are Works of Art." *Detroit News*, September 30, 1984, p. L1.

Thomas Gladysz. "Harry Callahan's Personal Vision." *Michigan State News*, October 1, 1984.

Peggy Page. "These Family Photos Aren't Snapshots." *Ann Arbor News*, October 7, 1984.

Ira Lax. "Callahan Gives a Personal View of Family." *Birmingham Eccentric* (Birmingham, Michigan), November 8, 1984, p. 8E.

"Harry Callahan." *Current Biography*, November 1984, pp. 6-9.

1985 Catherine Fox. "Three Exhibits Honor Callahan's Achievements." *The Atlanta Constitution*, May 5, 1985.

Andy Grundberg. "Photography: New Work in Color by Callahan." *New York Times*, June 14, 1985.

R. Greetham. "Harry Callahan Retrospective 1941-1982." *British Journal of Photography* (London), June 14, 1985, pp. 661-62.

Peter Turner. "Callahan in Cardiff." *Creative Camera*, October 1985, pp. 7-8.

Peter Turner, editor. *American Images: Photography: 1945-1980*. Harmondsworth: Penguin Books/Barbican Art Gallery, 1985, pp. 102-6.

1986 Rod Slemmons. *Stills: Cinema and Video Transformed*. Seattle: Seattle Art Museum, 1986. Brochure for exhibition held January 30-March 16, 1986; cover image by Callahan.

Marcia Morse. "One Man's Way of Making Peace With Life." *The Sunday Star-Bulletin and Advertiser* (Honolulu), August 3, 1986, p. C11.

Keith Nicholson. "A Model Wife." *More* (Auckland, New Zealand), September 1986, "People" section, p. 13.

Peter Shaw. "Arts." *New Zealand Woman's Weekly*, September 8, 1986, p. 39.

T. J. McNamara. "Photographs Linger Long in Memory." *New Zealand Herald* (Auckland), September 22, 1986, Section 1, p. 11.

Gary Catalano. "Harry's Game." *The Age* (Melbourne, Australia), November 22, 1986, Living Supplement, p. 1.

1987 Clare Henry. "That Certain Essence Captured With Ease." *Glasgow Herald* (Glasgow, Scotland), January 9, 1987, p. 4.

John McDonald. "Photographer's Joy in the Commonplace." *Sydney Morning Herald* (Sydney, Australia), January 24, 1987, p. 42.

Robert McFarlane. "Harry Callahan's Colourful Life." *The Weekend Australian Magazine* (Sydney), January 31-February 1, 1987, p. 1.

Bruce Muirhead. "American Master's Work of 40 Years Goes on Show." *The Courier Mail* (Brisbane, Australia), April 4, 1987, p. 17.

Mariette Haveman, "Als Eleanor er is Staat Zij In Het Midden." *de Volkskrant* (Amsterdam), September 25, 1987, p. 21.

Chronology: 1978-87

Includes Selected One-Person Exhibitions, Travels, Lectures, and Awards

1978 Travels and photographs in Egypt, Syria, Jordan, and Israel, February 18-March 10.

Exhibition, Galerie Fiolet, Amsterdam, Holland, March 17-April 15.

Exhibition, Light Gallery, New York; first devoted to his color work; March 29-April 22.

Travels and photographs along the eastern seaboard from Montauk Point, New York, to Key West, Florida.

Exhibition, Galerie Zabriskie, Paris, France; July 5-August 5.

Selected by the International Exhibitions Committee of the American Federation of Arts to represent the U.S. at the 38th Venice Biennial (with painter Richard Diebenkorn). This marks the first time a photographer has been so honored. Callahan travels to Italy to attend the Biennial, which opens on July 2 and runs into October.

Exhibition, University of Arizona Museum of Art, Tucson, September 10-October 15. Callahan attends opening on September 10.

1979 Elected a Fellow of the American Academy of Arts and Sciences, Boston, Massachusetts, May 9.

Awarded honorary degree of Doctor of Fine Arts from Rhode Island School of Design, May 26.

Exhibition, Atlanta Gallery of Photography, Atlanta, Georgia, March 27-May 12.

Travels and photographs in Ireland.

Exhibition, "Harry Callahan: Photographs in Color: The Years 1946-1978" curated by Sally Stein and organized by the Center for Creative Photography. Tour schedule:

> October 14-Nov. 8, 1979
> Center for Creative Photography
> Tucson, Arizona

Jan. 21-Feb. 29, 1980
Museum of New Mexico
Santa Fe, New Mexico

May 10-June 23, 1980
Akron Art Institute
Akron, Ohio

Sept. 6-Nov. 2, 1980
Hudson River Museum
Yonkers, New York

Dec. 6, 1980-Jan. 15, 1981
Port Washington Public Library
Port Washington, New York

Travels and photographs in the South Pacific: Tahiti; Melbourne, Australia; Auckland, and by surface to Wellington, New Zealand; Fiji; Hawaii; and San Rafael, California; November 11-December 26.

Exhibition, Photographer's Gallery, Melbourne, Australia, November 16-29; Callahan lectures at opening.

Exhibition, University of Hawaii at Manoa, Honolulu; Callahan presents lecture on December 13.

1980 Exhibition, Miami-Dade Community College, Florida, March 17-28.

Travels to New England, New York, Pennsylvania, and North Carolina at various times during February-August.

Visits Cape Cod, July 16-31.

Travels to Bay of Fundy, Nova Scotia, August 7-14.

Exhibition, Light Gallery, New York, September 12-October 4; Callahan attends opening.

Exhibition, Jane Corkin Gallery, Toronto, Ontario, October 4-29; Callahan attends opening.

Travels in Canada, October 4-28.

Lecture, Boston Public Library, Boston, Massachusetts, November 13.

Lecture, Port Washington Public Library, December 8.

1981 Receives first "Distinguished Career in Photography" award from the Friends of Photography, Carmel, California. Presentation ceremony held in New York City on January 20.

Exhibition, "Harry Callahan: Photographs" curated by Keith F. Davis from Hallmark Photographic Collection. Callahan attends opening at Spencer Museum of Art on January 17. Tour schedule:

> January 17-March 1, 1981
> Spencer Museum of Art
> University of Kansas
> Lawrence, Kansas

> March 29-May 10, 1981
> University Art Museum
> University of New Mexico
> Albuquerque, New Mexico

> August 16-September 27, 1981
> Museum of Art
> Duke University
> Durham, North Carolina

> October 25-December 6, 1981
> Sheldon Memorial Art Gallery
> University of Nebraska
> Lincoln, Nebraska

> January 17-February 28, 1982
> California Museum of Photography
> University of California-Riverside
> Riverside, California

> March 16-May 9, 1982
> Stanford University Museum of Art
> Stanford University
> Stanford, California

> June 18-July 31, 1982
> Columbia Gallery
> Columbia College
> Chicago, Illinois

August 23-September 15, 1982
University Museum
Southern Illinois University
Carbondale, Illinois

October 3-November 7, 1982
Ohio State University
Columbus, Ohio

Travels and photographs in Morocco, January 21-February 11; drives 2,500 miles.

Exhibition, Eclipse Photographs, Boulder, Colorado, February 22-March 2; Callahan attends opening.

Lecture, Shepherd College, Shepherdstown, West Virginia, April.

Exhibition, Colorado Mountain College, Breckenridge, Colorado, July 1-26. Callahan attends opening and participates in symposium, "Still Life: Aspects of Representation," July 1-8.

Travels through England and Scotland with daughter Barbara and son-in-law Michael Hollinger, July 14-August 19.

Lecture, Corcoran Gallery, Washington, D.C., September 22.

Travels to Freeport, Bahamas, December 3-10.

1982 Exhibition, Columbus Museum of Art, Columbus, Ohio, January 9-24. Callahan presents lecture.

Travels to Mexico City, Campeche, and Oaxaca, Mexico, February 19-March 15.

Exhibition, J. B. Speed Museum of Art, Louisville, Kentucky, March 15-April 18; Callahan lectures at museum on March 19.

Lecture, Smithsonian Institute, Washington, D.C., May 3.

Exhibition, The Clemons Gallery, Houston, Texas, May 7-June 5.

Travels and photographs in Vermont and around Lake Champlain, New York, May 17-21; and in

Chicago, North Carolina, and Atlanta, May 26-June 23.

Honored by Vice-President and Mrs. Walter Mondale for contributing to portfolio "Views of America," published to raise funds for Democratic candidates in 1982 elections, June 1, in Washington, D.C.

Travels to Cape Cod, July 8-11, and to New York and Michigan, July 26-August 10.

Exhibition at Dalsheimer Gallery, Baltimore, Maryland, September 7-October 15; Callahan attends opening reception on September 12.

Travels and photographs in Portugal, September-October.

Exhibition, PPS Galerie, Hamburg, Germany, September 22-October 30.

Death of sister, Alice McKinnon, in Port Huron, Michigan, October 9.

1983 Exhibition, "Harry Callahan and His Students: A Study in Influence," organized by Louise E. Shaw, Virginia Beahan, and John McWilliams for the Art Gallery, Georgia State University, and circulated by the Southern Arts Federation. Callahan participates in symposium on January 21. Complete tour schedule:

January 5-February 4, 1983
Art Gallery, Georgia State University
Atlanta, Georgia

July 2-August 28, 1983
Museum of Arts and Sciences
Macon, Georgia

September 13-October 16, 1983
University of Illinois
Chicago, Illinois

February 7-March 11, 1984
Northern Kentucky University
Highland Heights, Kentucky

Travels and photographs in Miami Beach,

Florida, and Isla de Mujeres, Mexico, January 29-February 19.

Birth of granddaughter, Emily Erin Hollinger, March 16.

Travels to Tokyo, Japan, May 20-June 10; and to China, June 10-29.

Exhibition, Seibu Museum of Art, Tokyo, Japan, May 28-June 21.

Exhibition, "Recent Color Photography," Zabriskie Gallery, New York, June 1-July 1.

Exhibition, "Harry Callahan: Photographs," from Hallmark Photographic Collection, at National Gallery of Ontario, Toronto, Canada, August 26-October 16; Callahan attends opening on August 26.

Exhibition, Princeton Gallery of Fine Arts, Princeton, New Jersey, September-October 15.

Lecture, Portland School of Art, Portland, Maine, October 12.

Exhibition, "Harry Callahan: New Color Photographs of Ireland and Morocco," Thomas Segal Gallery, Boston, November 5-30.

Moves from Providence, Rhode Island, to Atlanta, Georgia, in December; retains house in Providence for use during summer months.

1984 Exhibition, "Eleanor: Photographs by Harry Callahan," curated by Peter MacGill and circulated by the Center for Creative Photography. Tour schedule:

January 18-March 14, 1984
The Art Institute of Chicago
Chicago, Illinois

March 30-June 24, 1984
San Francisco Museum of Modern Art
San Francisco, California

September 18-November 25, 1984
The Detroit Institute of Arts
Detroit, Michigan

January 15-March 16, 1985
The Museum of Fine Arts
Houston, Texas

March 31-April 25, 1985
Center for Creative Photography
Tucson, Arizona

September 8-October 27, 1985
Snite Museum of Art
University of Notre Dame
Notre Dame, Indiana

Exhibition, "Harry Callahan: Chicago Photographs," Edwynn Houk Gallery, Chicago, Illinois, January 17-March 31.

Exhibition, "Harry Callahan: Eleanor and Barbara," Fay Gold Gallery, Atlanta, Georgia, April 21-May 15.

Exhibition, "Harry Callahan: Eleanor and Barbara," Zabriskie Gallery, New York, April 24-June 1.

Exhibition, Anne Weber Gallery, Georgetown, Maine, July 15-September 3; subsequently shown at Colby College Museum of Art, Waterville, Maine, September 9-November 4.

1985 Travels and photographs in Jamaica, January 17-24.

Travels and photographs in Hong Kong, Taiwan, and Bangkok, March 14-30.

Awarded 1985 Brandeis Creative Arts Medal in ceremony at the Solomon R. Guggenheim Museum, New York, May 1.

Exhibition, Pace/MacGill Gallery, New York, May 2-June 15.

Travels and photographs in Cardiff, Wales; Helsinki, Finland; and Leningrad, Russia; May 5-June 5.

Exhibition, "Harry Callahan Retrospective 1941-82," organized by the Ffotogallery in Cardiff, Wales, and circulated throughout the U.K. Calla-

han attends opening in Cardiff. Complete tour schedule:

May 9-June 15, 1985
Ffotogallery
Cardiff, Wales

August 10-September 7, 1985
Axiom Centre for the Arts
Cheltenham, England

September 12-October 12, 1985
Open Eye Gallery
Liverpool, England

October 19-November 16, 1985
Brewery Arts Centre
Kendal, England

November 30, 1985-January 4, 1986
Plymouth Arts Centre
Plymouth, England

January 28-March 23, 1986
National Museum of Film, Photography and TV
Bradford, England

April 4-May 1, 1986
Astley Cheetham Gallery
Manchester, England

May 10-June 7, 1986
The Royal Museum and Art Gallery
Canterbury, England

July 4-August 2, 1986
The Untitled Gallery
Sheffield, England

August 16-September 20, 1986
Artspace
Aberdeen, Scotland

October 1-31, 1986
Aberystwyth Arts Center
Aberystwyth, Wales

January 9-February 7, 1987
Collins Gallery, Strathclyde University
Glasgow, Scotland

March 7-28, 1987
Shire Hall
Presteigne, Wales

April 11-May 11, 1987
Camden Arts Centre
London, England

Exhibition, Allen Street Gallery, Dallas, Texas, September 7-October 13 (from Hallmark Photographic Collection); Callahan attends reception and gives lecture on September 6.

1986 Birth of second granddaughter, Allison Diana Hollinger, July 1.

Exhibition, "Harry Callahan: Photographs," curated by Keith F. Davis from Hallmark Photographic Collection. Tour itinerary:

July 9-August 17, 1986
Honolulu Academy of Arts
Honolulu, Hawaii

August 29-October 12, 1986
Auckland City Art Gallery
Auckland, New Zealand

November 12, 1986-January 4, 1987
National Gallery of Victoria
Melbourne, Australia

January 22-March 8, 1987
Art Gallery of New South Wales
Sydney, Australia

March 20-May 10, 1987
Queensland Art Gallery
Brisbane, Australia

Lecture, San Francisco Art Institute, August 15.

Travels and photographs in Barcelona, Madrid, and Palma de Majorca, Spain, November 20-December 10.

1987 Lecture, Santa Barbara Museum of Art, Santa Barbara, California, January.

Lecture, Yale University, New Haven, Connecticut, March 2.

Lecture, California State University, Fullerton, April 10.

Exhibition, De Beijerd, Center for Visual Arts, Breda, Holland, September 12-November 1; this exhibit also presented at Bouwfonds Nederlandsche Gemeenten, Hoevelaken, Holland, January 8-February 5, 1988.

Exhibition, Columbus College, Columbus, Georgia, September 23-October 9; Callahan lectures on October 5.

Exhibition, Drew University, Madison, New Jersey, October 7-28.

Exhibition, "Harry Callahan: Vintage Photographs," Pace/MacGill Gallery, New York, October 15-November 28.

Exhibition, Olympus Gallery, Amsterdam, Holland, November 29-December 20.